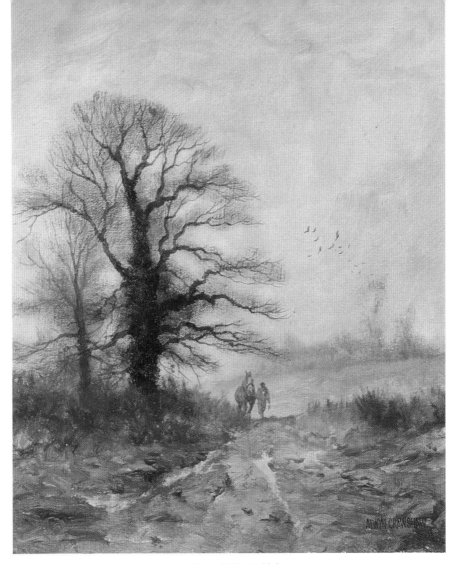

HarperCollins*Publishers*
1 London Bridge Street
London SE1 9GF

First published in 1979
by William Collins Sons & Co Ltd, London

This edition published by HarperCollins*Publishers* 2019

www.harpercollins.co.uk

1 3 5 7 9 10 8 6 4 2

Designed, edited and typeset by Flicka Lister
Photography by Nigel Cheffers-Heard and Michael Petts

A catalogue record for this book is available from the British Library

ISBN 978-0-00-745869-1

Printed and bound in China

Learn to Paint

Acrylics

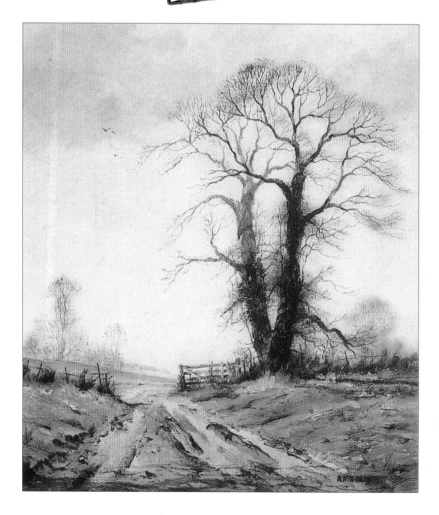

Alwyn Crawshaw

Contents

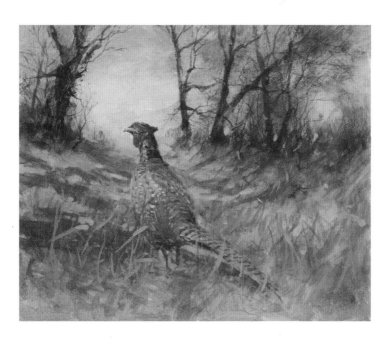

Previous Page: **Off Home**, *acrylic on canvas*, 30 x 25 cm (12 x 10 in)

This Page: **Norfolk Pheasant**, *acrylic on primed hardboard*, 25 x 28 cm (10 x 12 in)

Portrait of the Artist

Successful painter, author and teacher Alwyn Crawshaw was born at Mirfield, Yorkshire, and studied at Hastings School of Art. He now lives in Norfolk with his wife June, who is also an artist.

Alwyn is a Fellow of the Royal Society of Arts, and a member of the British Watercolour Society and the Society of Equestrian Artists. He is also President of the National Acrylic Painters Association and is listed in the current edition of *Who's Who in Art*. As well as painting in watercolour, Alwyn also works in oil, acrylic and occasionally pastel. He chooses to paint landscapes, seascapes, buildings and anything else that inspires him. Heavy working horses and winter trees are frequently featured in his landscape paintings and may be considered the artist's trademark.

This book is one of eight titles written by Alwyn Crawshaw for the HarperCollins *Learn to Paint* series. Alwyn's other books for HarperCollins include: *The Artist At Work* (an autobiography of his painting career), *Sketching with Alwyn Crawshaw, The Half-Hour Painter, Alwyn Crawshaw's Watercolour Painting Course, Alwyn Crawshaw's Oil Painting Course, Alwyn Crawshaw's Acrylic Painting Course* and *Alwyn & June Crawshaw's Outdoor Painting Course*.

To date Alwyn has made seven television series: A *Brush with Art, Crawshaw Paints on Holiday, Crawshaw Paints Oils, Crawshaw's*

▲ Alwyn Crawshaw working outdoors.

Watercolour Studio, *Crawshaw Paints Acrylics*, *Crawshaw's Sketching & Drawing Course* and *Crawshaw Paints Constable Country*, and for each of these he has written a book of the same title to accompany the television series.

Alwyn has been a guest on local and national radio programmes and has appeared on various television programmes. In addition, his television programmes have been shown worldwide, including in the USA and Japan. He has made many successful videos on painting and is also a regular contributor to the *Leisure Painter* magazine and the *International Artist* magazine. Alwyn and June organize their own successful and very popular painting courses and holidays. They also co-founded the Society of Amateur Artists, of which Alwyn is President.

Alwyn's paintings are sold in British and overseas galleries and can be found in private collections throughout the world. His work has been favourably reviewed by the critics. *The Telegraph Weekend*

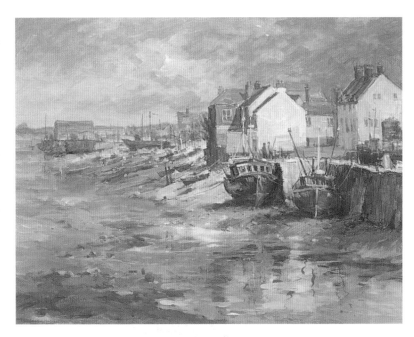

Magazine reported him to be 'a landscape painter of considerable expertise' and the *Artists and Illustrators* magazine described him as 'outspoken about the importance of maintaining traditional values in the teaching of art'.

▲ **A Norfolk Fishing Harbour**
primed hardboard
30 x 40 cm (12 x 16 in)
I was inspired to do this painting by the sunlight hitting the buildings.

◀ **Willows at Potter Heigham, Norfolk**
primed hardboard
12 x 28 cm (10 x 12 in)
When I came upon this scene, I was inspired by the strong sunlight. The dark rain clouds and heavy shadows on the trees in the middle distance made the picture even more dramatic.

Introduction

Why use acrylic colours? I am constantly asked this question. The answer is that I like using them and they suit my personality. I believe that a painting comes from the inner self and this gives it the mood, the atmosphere, the invisible quality that makes it look alive. If you were inspired to paint a particular landscape and could paint it in, say, three minutes while that urge was there, then the painting would express your uninterrupted feelings on the canvas.

Now, three minutes to paint a picture is ridiculous but, because acrylic colours dry so quickly, a certain speed is possible. As one stage of the painting is done, you can overpaint almost immediately without

▼ How Much Longer
Have We To Wait?
detail on canvas
25 x 25 cm (10 x 10 in)

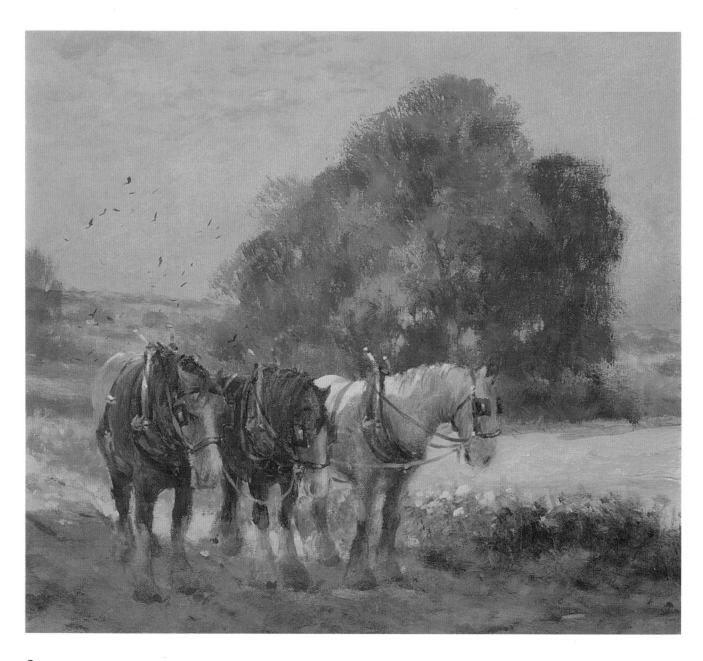

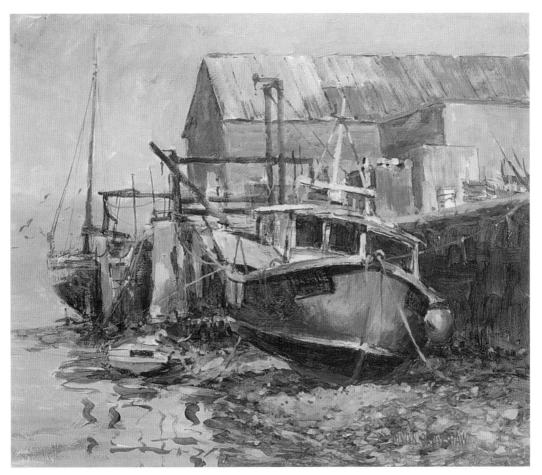

◀ **The Red Boat, Norfolk**
primed hardboard
25 x 28 cm (10 x 12 in)
I couldn't resist this red boat and all the quayside structures, which I spotted when painting the *Norfolk Fishing Harbour* scene on page 5. You can just see the red boat at the extreme left of that painting.

picking up the paint from underneath and consequently you can keep working while the inspiration is there.

If circumstances permit, you can start a painting in the morning and finish it in the afternoon, as each stage will be dry enough for you to follow on with the next. If you like to put detail in a picture, this can be done as and when you feel it necessary because the paint will dry quickly enough to allow you to work on top of the previous layer.

This direct way of painting is one of the reasons why acrylic painting suits me. Another very useful factor is that no smell is given off when using acrylics, unlike oils.

Naturally, as with all painting, there are techniques to be learned and certain disciplines to be acquired before you can master the medium. As the reader of this book, you have taken your first big step. If you are a beginner, curious about painting and wanting to find out more about it, you

have selected acrylics as the medium with which to start. If you already paint and are reading this book to learn about the medium of acrylic colour then, whatever other medium you paint in, do start with the basic exercises. Remember, a new medium requires different techniques.

I will take you through this book stage by stage, working very simply to start with and progressing to a more mature form of painting. If you have some acrylic colours, your desire to try them out will most probably have been stimulated by looking through the book and seeing the variety of images and different methods of working. However, I strongly recommend that you relax and read on before you actually pick up a brush. More haste – less speed!

If you find some exercises difficult to master, go a stage further and then come back. Seeing a problem with a fresh eye will make it easier to solve. Good luck!

What are Acrylic Colours?

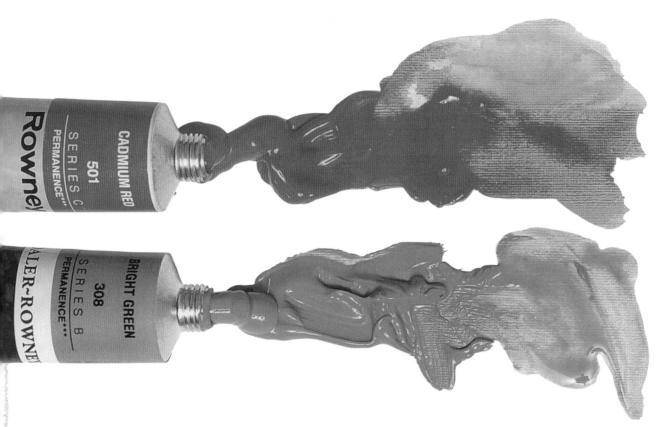

Acrylic colours first arrived on the market in this country in 1963. Daler-Rowney produce two ranges of acrylic colour which I use, Cryla Colour and Cryla Flow Colour.

Cryla Colour is very thick, has a buttery texture similar to oil colour and comes in a small tube. Because of its consistency it is used mainly for palette knife work. As with oils, an acrylic painting can be built up to achieve a tremendous amount of relief work (impasto). The immediate advantage of acrylics over oil colours used in this way is that oils take months to dry but acrylics take only hours, even when put on really thickly.

I prefer to use brushes with this medium. This is where the other type of acrylic colour, Cryla Flow Colour, comes in, as it is better to use with a brush. Unless stated, I have used Cryla Flow Colour for all the exercises in this book. This type of acrylic colour comes in a longer tube. You can add Gel Retarder to slow down the drying time and use Texture Paste for building up heavy impasto. There are also high-quality nylon brushes on the market, which I use all the time and find best for all my acrylic painting, apart from small detail work.

A Stay-Wet Palette keeps the paint wet on the palette almost indefinitely, saving a lot of paint from being wasted by the paint drying too soon. I strongly recommend the use of this.

A choice of techniques

One very unique and exciting property of working with acrylic colour is that you can paint in an 'oil' painting technique or in a 'watercolour' painting technique, or use both techniques in the same picture – see my two paintings *(right)*. These two different ways of working are described later in the book.

▲ The paint in the red tube is Cryla Flow Colour. The paint in the green tube is Cryla Colour.

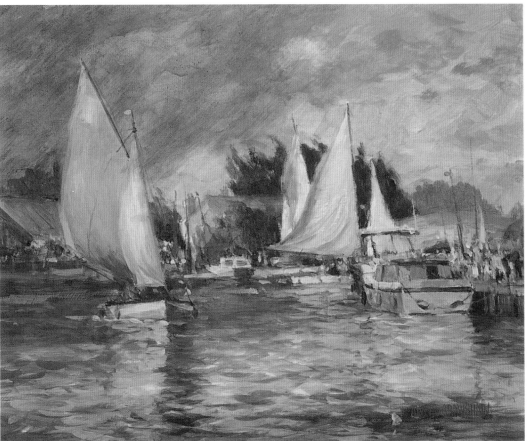

▲ The Snow Drift
acrylic watercolour technique on Waterford watercolour paper 300 lb Rough
50 x 75 cm (20 x 30 in)
I worked this painting without using any white paint – just as I would a watercolour. The dark sky helps to make the snow (unpainted white paper) look even whiter.

◄ Yachts and Wind, Potter Heigham
acrylic oil technique on primed hardboard
25 x 28 cm (10 x 12 in)
Notice how much movement there is in this painting. The clouds, the yacht sails and the water all help to give the illusion of a busy, blustery, sunny day. I painted it with my normal oil technique.

Materials and Equipment

Equipment can vary from basic essentials to a whole roomful of easels, boards, canvases and so on. I tend to collect brushes and have far more than I will ever use but enjoy the feeling that somewhere I have a brush for the job! Anything beyond the basic equipment, I think, must be left to your personal choice. All the exercises in this book have been done with the basic kit which is shown on page 13.

Colours

Acrylic colours come in tubes, so get into the discipline of putting the cap back on, or the colour will start to dry out. You mix the colour with water, not white spirit or turpentine, and wash brushes out in water.

There are many colours to choose from, but I use what is called a 'limited palette'. This simply means that I don't use many colours and is quite a common practice among artists. The colours I use for all my acrylic paintings and for those in this book are shown below. These are all Cryla Flow Colours but I suggest you also use Raw Umber and Bright Green in Cryla Colour. I use these to add texture to landscape foregrounds. With experience, you may wish to use other colours – and materials – but first try to get used to the basic equipment, particularly if you're a beginner.

Crimson

Cadmium Yellow

Ultramarine

Bright Green

Raw Umber

Raw Sienna

Cadmium Red

Coeruleum

Burnt Umber

Titanium White

◀ These are the colours I use for painting in acrylics. I use the colours in the first column, plus Titanium White, much more than the colours in the second column.

Palette

The Daler-Rowney Stay-Wet Palette is available in two sizes and will keep your paints wet almost indefinitely. I've used mine constantly since these first came on the market over fifteen years ago. When you squeeze your paint out on to the palette, always put the colours in the same position. The way in which you pick up colours from your palette must become second nature as you will have enough to worry about without searching for a particular colour!

If you are not using a Stay-Wet Palette, then you can use either a glass or plastic surface, or even a dinner plate to mix your colours on but remember that the paint will start to dry while you are working so don't put out more paint than you will be able to use at one sitting.

Brushes

These are the tools of the trade with which you will create shapes and forms on your canvas and are by far the most important working equipment you will ever buy. Invest in the best quality you can afford – remember, it is the brush that allows your skills to be expressed.

However, don't treat your brush as a show piece when you are working with it. The brush has to perform different movements and accomplish many different shapes and patterns. If it means that you have to push the brush against the flow of the bristles, don't be afraid to do so. This way it will gradually become adaptable for certain types of work; you will get to know what these are with practice. The Cryla brushes shown (right) are excellent. They are made specially for acrylic painting and have synthetic bristles. This series has five different types of brushes and the type I use is the Cryla Series C25, long-handled.

Incidentally, I suggest that you use a No. 12 size brush in the Cryla Series C25 (not shown here). I use my No. 10 brush occasionally but a No. 12 covers areas more quickly, which you will find useful.

Another good brush I use sometimes is a Bristlewhite B.48 hog hair brush. The bristles have more resistance than Cryla brushes. In addition, I use my 'Rigger' brush (which also has synthetic hairs) for thin lines and small detail work, and my round sable No. 6 for delicate work.

▲ There is no magic about the way I place the colours on my Stay-Wet Palette. I started this way and have stuck with it ever since. However, because the colour layout works well, I suggest you adopt it, too. I use these ten colours but I normally use Ultramarine, Crimson, Cadmium Yellow, Bright Green and Titanium White for about 70% of any painting.

◀ The four brushes on the left are Cryla Series C25, long-handled. The red-handled brush is a Dalon 99 'Rigger' No. 2, and next to it is a round sable No. 6.

▲ The painting knife is used for palette knife painting but I prefer to work with a brush and so this book does not include this type of painting. But if you want to try it, don't let me stop you – go ahead and enjoy it.

Caring for your brushes

It is advisable to keep your nylon brushes in water all the time. I have brushes that have lived in water now for over ten years and since I have been using this method, none have gone hard because of paint drying on them. If by accident you let a brush get hard, soak it overnight in methylated spirit, then work it between your fingers and wash it out in soap and water.

When you finish using a brush, even if you know you will need it again in a few minutes, put it back in your brush dish; make this one of your first disciplines. When you take it out of the brush dish to use again, dry it out on rag – keep some handy at all times for this purpose.

Only use a damp brush when working normally as the acrylic's own consistency is all you need, unless you are working a watercolour technique. If you use sable brushes, however, never leave them in water – wash them out immediately after use.

Mediums

The medium used for mixing acrylic paint is water but you can add other mediums to the paint or to the water to achieve different results.

Cryla Gel Retarder slows down drying time and you can mix Texture Paste with the paint to thicken its consistency. Glaze Medium can be mixed with acrylic colours to make them more transparent for over-glazing.

Soluble Varnish (available in a matt or gloss finish) is an acrylic varnish which is removable with white spirit or turpentine. It isn't necessary to varnish an acrylic painting but, if the picture is to be framed without glass, varnishing will help protect its surface.

Painting surfaces

There are many painting surfaces (grounds) on which you can work. You must make sure that the surface is free from oil or grease and, if it is too absorbent for you, then it must be primed with Cryla Acrylic 'Gesso' Primer. You may need up to three coats of this, depending on the surface you are priming. An oil-primed canvas must always be over-primed with Acrylic Primer. When you are using a watercolour technique, it isn't necessary to prime the paper.

To practise, use the least expensive ground. If you work on an expensive one, you will probably be hesitant to experiment, and your thoughts will be more on your pocket than your painting!

Cryla Primed Paper is made specially for acrylic painting and I have used it for a lot of the work in this book. It is available in spiral-bound sketchbooks in sizes ranging from 17 x 13 cm (7 x 5 in) to 50 x 40 cm (20 x 16 in) and I recommend this as a good all-purpose paper.

The least expensive paper to work on is brown wrapping paper, which you can use primed or unprimed. You can even work on newspaper, primed or unprimed, but I suggest you only use this to practise on because it is easily torn and you wouldn't want to damage your first masterpiece!

Cartridge drawing paper is another inexpensive support. You will find it easier to work on this if you prime it first. Interior quality hardboard (primed on the smooth side) is also very good. You can buy ready-primed canvas boards in varying sizes and you can work on any watercolour paper.

Finally, there is canvas and you can buy this ready-primed for acrylic painting.

▶ These are some of the various surfaces (grounds) you can paint on.

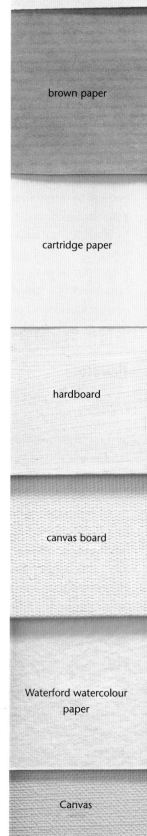

Cryla sketchbook paper

brown paper

cartridge paper

hardboard

canvas board

Waterford watercolour paper

Canvas

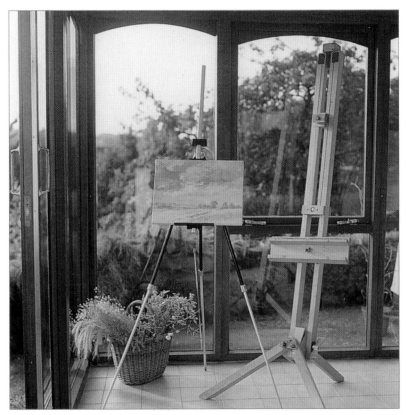

▲ A lightweight portable easel and a studio easel.

without an easel (use a chair), and you can work on acrylic-primed paper – not expensive canvas – so you don't need Acrylic Primer.

The Cryla Flow Colours you will need are the ones shown on page 10, but if you wish to cut the quantity down you could manage with just the five colours in the first column, plus Titanium White, for most of the work. For some of the exercises, you will need Bright Green and Raw Umber in Cryla Colour (that is the thicker paint). Your brushes are the Cryla Series C25 Nos. 12, 10, 8 and 4. You will also need a Dalon Series D99 'Rigger' No. 2 and a Kolinsky Sable Series 43 No. 6.

You will need a Stay-Wet Palette, large or small; a Cryla sketchpad 50 x 40 cm (20 x 26 in), or a painting surface of your choice – and don't forget brown paper! You will also need HB and 2B pencils, a plastic eraser, some rag, a water jar, a brush dish, and a tube of Gel Retarder (if you feel you need it), although I didn't use this in any of the exercises in the book.

Easels

If you are working with an oil painting technique, you will need an easel to hold your painting surface upright. The photograph (above) shows two easels: the black and silver one is portable, and the wooden one is a studio easel and really for indoor use only. If you've no room for an upright easel, you can buy a table easel, or put your painting surface on the seat of a kitchen chair, resting in an upright position against the back. Easels vary a great deal in size, type and cost. I suggest you try some out in an art supply shop and decide what suits both you and your pocket. An easel isn't necessary if you are working in the watercolour technique – all you will need is a drawing board to support your pad or paper.

Basic Kit

The materials shown (right) are all you need to get started and to work through the exercises in this book. I have just said that you can work

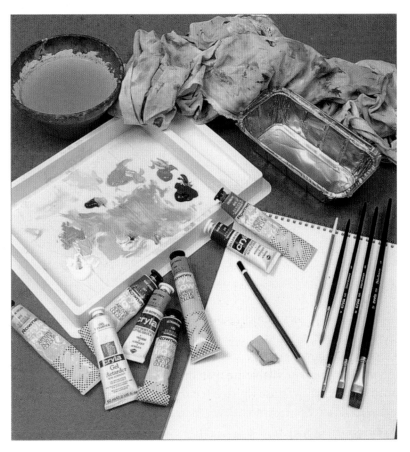

▲ Basic Kit

Mixing Colours

If you are new to painting, it may seem impossible to mix each of the hundreds of colours that we see around us. However, this can be done by using only red, yellow and blue – the primary colours. Of course, you can get different reds, yellows and blues to help mix the colours you want. But, in general, you should be able to paint a picture using just one of each of the primary colours.

Many colours are mixed from just two colours. For instance, green is mixed from yellow and blue. If you wanted a warmer (browner) green then you would need to add a little red to your mix. This is where colour mixing gets a little more complicated – if you tried to get the warm green by mixing equal parts of yellow, blue and red, you would make a dark mud colour.

Getting the mix right

So how do you judge the correct quantity to mix to get the correct colour? You will discover this by practising but the golden rule that you must follow is: the first colour you put onto your mixing area must be the predominant colour you are trying to create. For example, if you want to mix, say, a reddish-orange, you put red into the mixing area and then add a smaller amount of yellow. Don't put the yellow brush straight into the red; work into the red until you have the desired reddish-orange. If you start with yellow in the mixing area and then add a smaller amount of red, you will make a yellowish-orange. You would eventually get a reddish-orange by adding more and more red, but you would mix more paint than you need. It could be very frustrating and time-wasting.

Using white paint

In acrylic colour, white paint is used to make colours lighter (*see the colour chart, right*). If you are mixing a light colour, then you must start with Titanium White and mix into that.

Local colours

Although you can paint a picture using three primary colours, a good reason for having more colours is to be able to use them for local colours. A local colour is the colour of an individual object: for example, a particular red car, blue boat, yellow flower, etc.

Using the right colour is important when you are painting a picture but don't worry about it or keep re-mixing if your colour is a little different from the real-life colour. You don't have to be exact. Everyone can learn to mix colours. Experience is a great teacher! You will experience a wonderful feeling of success when you are able to mix the colours you need.

Always note the first colour shown on the exercise or specified in the text when you are mixing colours. This is usually the main colour of the mix, with other colours added in smaller amounts.

You may have noticed that my palette doesn't include black. Some artists use black, others don't. I am one of those who don't. I believe it is too flat – a dead colour, in fact – so I mix my blacks from the primary colours.

There are two ways of making acrylic colours lighter or paler. You can mix white paint with your colours or simply add water to make the paint transparent and lighter, as in watercolour painting.

▶ In these colour mixing examples, you will see that I have used three primary colours, plus white, and created other colours from them. Mixing colours can be rather frustrating at first but it can also be very enjoyable. The more you practise, the sooner it will become second nature, so don't think of this as a lesson, but as an exciting adventure!

Primary colours

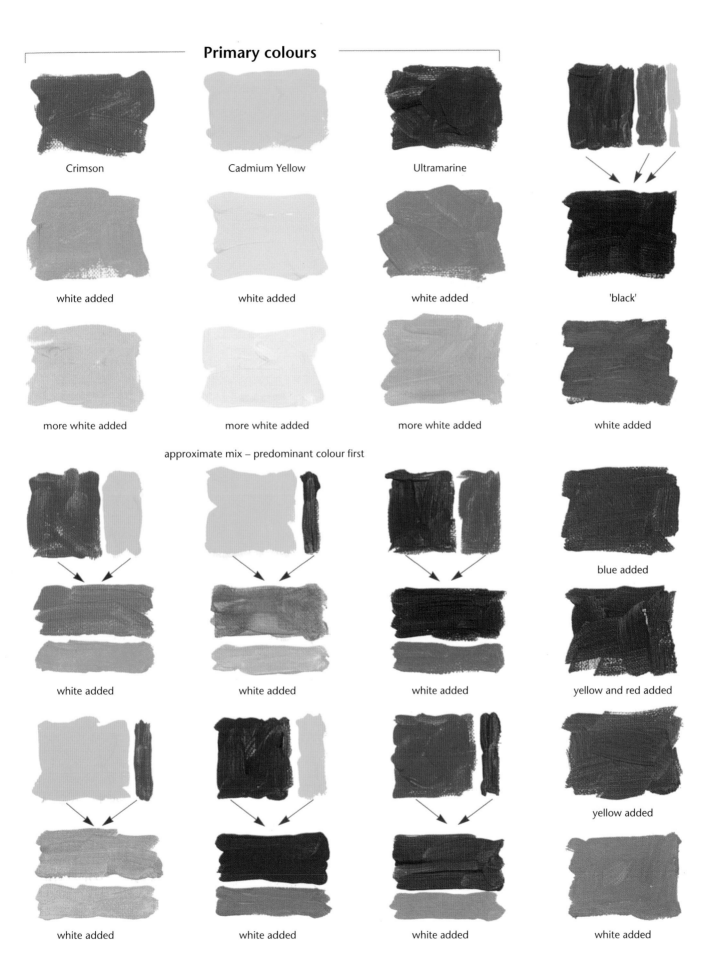

Crimson

Cadmium Yellow

Ultramarine

white added

white added

white added

'black'

more white added

more white added

more white added

white added

approximate mix – predominant colour first

white added

white added

white added

blue added

yellow and red added

white added

white added

white added

yellow added

white added

15

Brush Control

▶ Painting up to a line

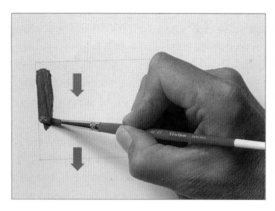

▶ Filling in an area

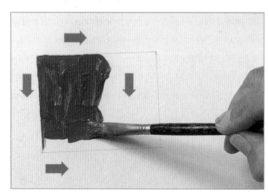

▶ Painting a thin line

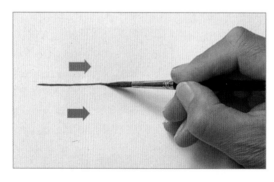

▶ Dry brush stroke

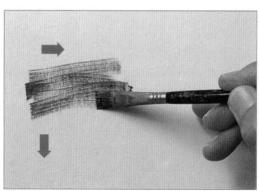

Because you can work in both oil and watercolour techniques with acrylics, the brush strokes that you will use are the same as those used for oil and watercolour painting. Naturally, some brush strokes are more suited to one technique than the other and your own experience as you progress will guide you.

I have shown some basic brush strokes on these two pages that form the foundation to applying paint to paper. I have also used two types of arrow to help you to understand the movement of the brush strokes. The red arrow shows the direction of the brush stroke and the blue arrow shows the direction in which the brush is travelling across the canvas. I use these arrows throughout the book.

As I said earlier, unless you are painting with the watercolour technique you should only use a damp brush because the paint's own consistency is perfect for this purpose. However, if you are using a small sable brush to paint detail, make your paint more watery than normal, or the paint will not run freely from the brush. For the watercolour technique, your paint must be mixed with plenty of water but I will tell you more about this on page 30.

For detail work, always hold your brush near the bristles as you would a pen or pencil (controlled position). If you want more freedom with the stroke, then hold the brush about 7.5 cm (3 in) away from the bristles.

Painting up to a line

An important brush stroke to master is painting carefully up to a line or shape before filling the area in with colour. For this, hold the brush in the controlled position. Start painting the area before the line, and work up to it. This gets your brush working and also gives you better control as you finally paint up to the drawn line. Work downwards where possible.

Filling in with paint

After painting your line around a shape, you can either fill the shape in with the same brush (loaded with plenty of paint) or use a larger brush. Depending on your experience and the accuracy needed, you may be able to paint edges and fill in with the same large brush.

Painting a thin line

To paint a thin line or to outline a shape, get your brush to the desired point, with paint flowing easily from the bristles by working the brush on your palette. Then paint directly on to the paper. When working on a dry surface, resting your little finger on the canvas or paper to steady your hand makes things much easier.

Dry brush stroke

This is a very useful technique to master and is used a lot in all types of paintings, from still life to landscapes. Only load your brush about one-quarter full and drag it across the surface. As the paint is used, you will get a hit and miss effect. You can also create this by lifting the brush and pressing lightly on the surface. The rougher the texture of the surface, the more exaggerated the technique will be.

Practise your brush strokes and don't worry if you get better results or feel happier holding your brush differently to me. As you progress, you will also discover variations on these brush strokes which will become personal to you and give your work an individual character.

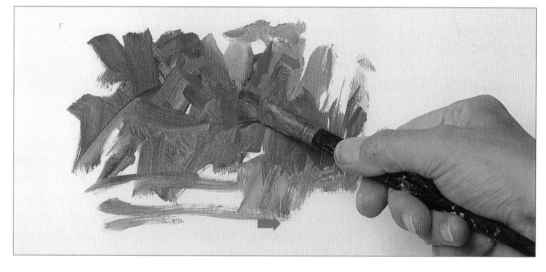

◀ To cover a large area, such as a background where no detail work is necessary, place the brush across the palm of your hand and hold it firmly with your thumb and first finger, and work the brush in any direction you want.

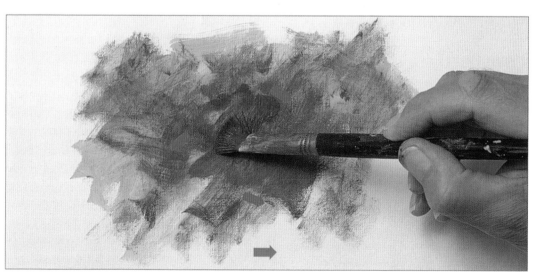

◀ Scumbling is another important brush stroke. This is usually worked over a dry underpainting, allowing areas to show through. To do this, hold your brush in the controlled position and scrub the brush in all directions.

Perspective, Shape and Form

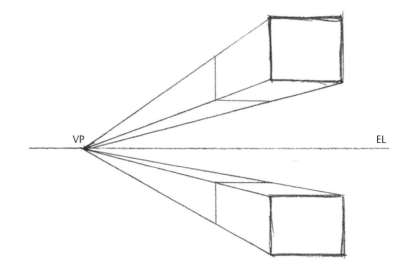

▲ Practise drawing boxes in perspective like this but use a different vanishing point (VP) and a different eye level (EL) each time.

Some people have a natural ability to draw in perspective – if you are one of them, this lesson will be relatively easy. If you are not one of the lucky ones, don't fight shy of the subject. Although you don't need to be an expert draughtsman to be able to paint pictures, you will be able to draw and paint more easily if you spend some time practising and mastering simple perspective.

Eye level and vanishing point

We will begin with the eye level. When you look out to sea, the horizon will always be at your eye level, even if you climb to the top of a cliff or lie flat on the sand. So the horizon becomes the eye level. If you are in a room, there is no horizon but you still have an eye level. To find this, hold your pencil horizontally in front of your eyes at arm's length – where the pencil hits the opposite wall is your eye level.

If two parallel lines were marked on the ground and extended to the horizon, they would appear to come together at what is called the vanishing point. This is the reason why railway lines appear to get closer together and finally meet in the distance – they have met at the vanishing point.

The basic rules of perspective

In all my books about painting and perspective, I use the same visual way of explaining the basic principles: that is a box or cube. Students often tell me that its simplicity makes it easy to understand, so I will use a box here, too. In the diagram (above right), I have drawn the eye level (EL) with a rectangle above it and one below. I then marked a spot to the left, on the eye level; this is the vanishing point (VP). On the top rectangle, I drew a line from each of the four corners, all converging at the vanishing point. This gave me the two sides, the bottom and the top of the box.

I did the same with the rectangle below it to create another box. You can see the underneath of the box and the top surface of the box below it. Remember, you see the underneath of anything that is above eye level, whereas you see the top of anything that is below eye level.

Try the simple experiment (below) - it will help you to remember this.

▶ Take a coin and hold it horizontally in front of your eyes (EL). All you will see is the edge of the coin (a straight line). If you move the coin up, keeping it level, you will see the underneath of it because it will be above your eye level. Move the coin down past your eye level (where it appears as just a line), until you can see the top of it. The coin is now being held below your eye level.

looking underneath coin

EL (coin flat)

looking on top of coin

Adding shape and form

To make a box look solid, we need to add tone by using light and shade (light against dark or dark against light). This gives the illusion of depth, dimension and perspective, i.e. making the box appear three-dimensional.

Look at these examples *(right)*. Although **a** is drawn in perspective, the box is just a flat shape without form because there is no light or shade. If there is a light source coming from above, as in example **b,** this adds tone and the box immediately takes on a form. The top has the lightest surface, the left side is darker in tone, and the right side (which is getting the least light) is the darkest.

Now let us see what else can be created from the same box shape, using light and shade in different ways. In **c,** I have used two dark tones to create a box without a lid, while **d** has become a lidless box on its side. With **e,** I have have taken things a stage further and created two separate solid blocks.

Although **f** is made up of light and dark tones, I have put a background behind it, making the whole box light against dark. However, if the background is the same colour and tone as the darkest side of the box, as in **g,** we lose the shape where it goes into the background. This technique is called 'lost and found' and at times you will want some shapes or edges to 'disappear', as this gives a painting interest and the appearance of reality. My last example also makes the point that if you don't have dark against light where two surfaces join, then you won't have form because you can't see anything. You will learn when to use this technique through your own experience.

Screwing up your eyes

When you are painting from life, screw up your eyes while looking at the scene in front of you to help you see shape and form. Try doing it right now. When you view something through half-closed eyes, the lights and the darks become exaggerated and the middle tones tend to disappear. This gives you simple contrasting shapes to follow.

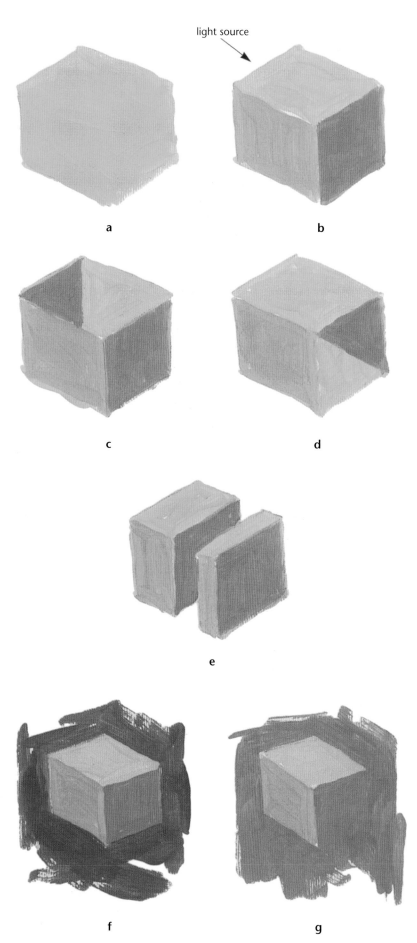

light source

a

b

c

d

e

f

g

Oil Technique

Before we venture any further, I would like to show you how acrylic paint behaves in different circumstances, and also how to use acrylics in different ways. This will help you to understand the nature of this medium a little more before you start to use it.

I know how difficult it is for you to keep reading this before actually experimenting with the paint but, as I have said earlier, try to be patient and read the whole book first before you do any practical work. Believe me, knowing the theory will be invaluable when you do start, and things will slot into place much more easily.

When I discuss watercolour as a medium with students, I often compare it to oil paint in order to explain its qualities and differences. However, I can compare acrylic colour to both watercolour and oils because of its similarities to both. This is because you can work acrylics from a thick impasto to a very watery, transparent wash.

This means that acrylics are extremely versatile. Of course, there are some things you can't do with acrylics that you can with oil paint and there are also things that you can't do with acrylics that you can do with watercolour. With practice, you will find out what these qualities are.

For the purpose of explaining how to use acrylic colour, I am first going to talk about using an oil technique. With this technique you can really use the paint to its maximum capacity and it is the technique that I use for most of my work.

On the following pages, I have shown different ways of using acrylic colour. These were done on Cryla Paper and painted 50 per cent larger than they are reproduced here. Next to each demonstration swatch, I have shown a close-up detail from one of my paintings to give you an example of where I have used this technique.

Impasto work

In the example *(below left)*, I have used Cryla Colour to paint impasto (thick). If you look at the detail of the tree trunks *(below)*, you can see where the thick texture has helped with the modelling of the trunks.

◀ Cryla Colour can be used to paint thickly for impasto work.

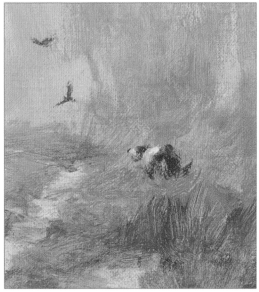

◀ The normal thickness of paint I use when working with Cryla Flow.

Normal consistency

The green swatch *(above)* was painted with Cryla Flow Colour and shows the normal consistency of this paint. It is used like this for most of an acrylic painting and the detail with the dog is a good example of this *(above right)*.

Scumbling

Scumbling is a technique whereby a thin layer of paint is brushed over another colour or tone in uneven, 'rough' brush strokes, allowing the under layer to show through. It gives a veiled or broken effect. I have already demonstrated the brush hold for this important technique on page 17.

If the technique is modified and applied more evenly, with less paint on the brush, it is very useful for applying 'mist' over already painted landscapes.

A sample of scumbling is shown in the brown colour swatch *(below left)* and you can see how I have used it to create a mist in the detail of the two horses, taken from one of my paintings *(below)*.

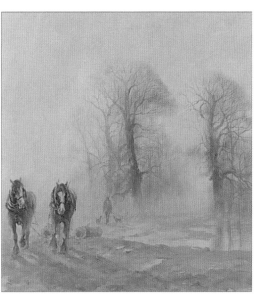

◀ Scumbling can be very effective when modified to create a mist over a landscape.

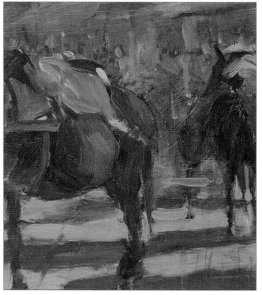

◀ When you paint opaquely over dry paint your brush strokes will cover up the colour underneath. This technique is used continually throughout a painting.

Painting opaquely

The ability to paint opaque colour over dry paint and cover it up by painting it out is very useful and you will find that acrylic paint, when applied over another painted area, has good covering powers.

In the example *(above left)*, you can see how Bright Green mixed with a little Titanium White has blotted out the brown colour underneath it. If you look at the detail from one of my paintings *(above right)*, you will see where I have used the paint opaquely for the loads on the donkeys' backs.

Using Glaze Medium

Mixing Glaze Medium into acrylic paint enables you to make a colour transparent without having to mix a lot of water with it. Experience will tell you whether to use it or not – I use it very little. In the example *(below left)*, I have painted some blue and yellow stripes mixing a little Glaze Medium with the paint. You can see how transparent the colours are – where they cross each other they make a green colour. The detail *(below right)* shows how I used this transparent effect to paint smoke from a fire over the background of the picture.

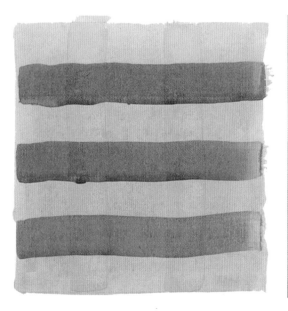

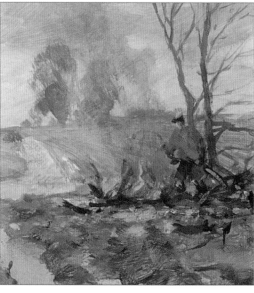

◀ Acrylic colours become transparent when you add Glaze Medium to the paint. The detail shows how it can be used to create smoke.

Incidentally, using Glaze Medium will give your colours a shiny effect but, if you varnish your work, it will not show.

Using Texture Paste

Texture Paste is a compound that you can mix with paint to thicken its consistency and can be used for building up heavy impasto. It dries with about the same speed as paint and, like paint, the thicker it is, the longer it takes to dry. It can be used for many things – making relief maps, even mending picture frames and so on! But I am only going to talk about its use for paintings.

I use Texture Paste when I want to exaggerate texture and when Cryla Colour by itself is not sufficient, mainly for the foregrounds in landscapes. Muddy paths and ploughed fields are my favourites.

I put a small lump of Texture Paste (approximately the size of a pea) on the canvas and work my colours into it, adding more Texture Paste as I need it.

Because it is white in colour, Texture Paste gives different shades and tones as it mixes with the colours. This is something that you can only appreciate through your own experiments, so you must try it yourself. I have painted my examples in an

Remember that Texture Paste is white and will make your colours lighter when it is mixed with them.

exaggerated way to show you how it can work.

Adding white Texture Paste makes colours lighter. To darken some areas, simply wait until the paint has dried and go over any area which you want to make darker or lighter. One word of warning, though – don't overdo the use of the Texture Paste. If you give too much relief to a foreground, for instance, it will look exaggerated or it may stand out and look alien to the rest of your picture. When I first started using Texture Paste, I was very excited about its possibilities and definitely overused it!

An example of the application of Texture Paste is shown *(below left)* and next to it is a detail showing how I have used it to paint a muddy path in one of my paintings.

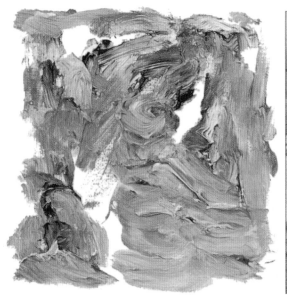

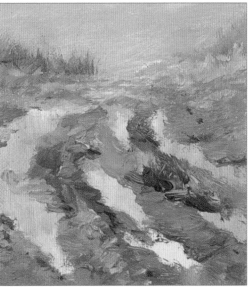

◀ You can obtain very thick relief by using Texture Paste but don't overdo it.

Simple Exercises

We are now ready to paint some simple and familiar objects. If you have practised with your colour mixing and drawing, you won't have much difficulty in copying what I have drawn, or in finding your own objects to paint from life.

The best way to start is by copying my illustrations. This will save you worrying about drawing problems when copying a real live object. However, after you have copied from the book, then get the object, set it up in front of you and have a go from the real thing. You will feel more familiar with the object itself, having painted it first from the book.

These simple objects must be treated freely so don't worry about detail. When painting from the real thing, remember to half-close your eyes to see the forms and the light and dark areas which simplify the shapes where the object is too complicated. Try to paint direct in these exercises – in other words, go for the colour you see and try to get it first time on the paper. These exercises are not meant to test your skill at painting detail but to give you experience in painting a whole picture, observing shapes and tones, and applying what you see to paper. We will use different supports (surfaces) on which to paint, starting with cartridge paper.

Paint a brick

Our first simple object is a brick and I am sure you can find one somewhere. Draw and paint the brick in the same way as the box on page 19 but, this time, try to paint each side separately with its own colour (the background was painted first). The top of the brick was next, using the colours shown, then the left side and, finally, the very dark side. The recess in the top of the brick was done last by adding shadow to its left-hand side.

▼ I did this exercise on cartridge paper, measuring 12.5 x 12.5 cm (5 x 5 in). I used Cryla Colour for the sides of the brick to add a little texture.

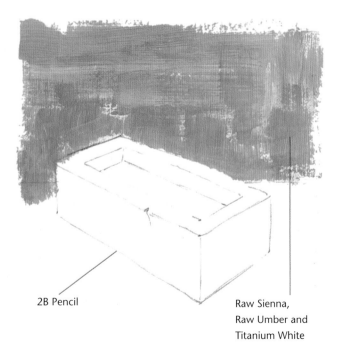

2B Pencil

Raw Sienna, Raw Umber and Titanium White

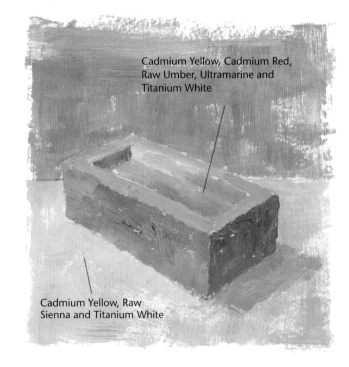

Cadmium Yellow, Cadmium Red, Raw Umber, Ultramarine and Titanium White

Cadmium Yellow, Raw Sienna and Titanium White

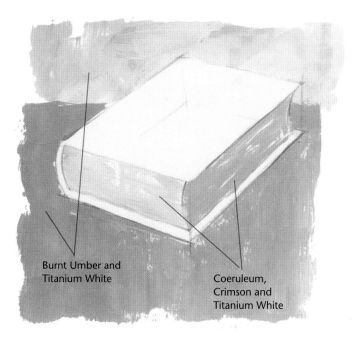

Burnt Umber and
Titanium White

Coeruleum,
Crimson and
Titanium White

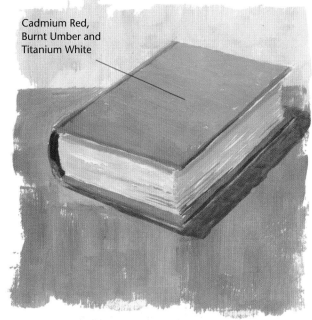

Cadmium Red,
Burnt Umber and
Titanium White

▲ This book was painted on cartridge paper, measuring 12.5 x 12.5 cm (5 x 5 in). After you have copied it, find one of your own and have a go. Remember to choose one with a plain cover.

Paint a book

Next, still working with a simple box shape, paint the book *(above)*. The shape is the same as the brick, and it has the same light and dark areas because the light source is coming from the same position, at the top left of the picture. Use a flat brush for the pages and work downwards – you will find that the brush strokes look like the edges of the pages. Look at a real book, half-close your eyes, and you will be surprised how dark the white pages are on the shadow side.

Paint an apple

Draw the apple first with a 2B pencil. Then, using your No. 10 Cryla brush and a mix of Cadmium Yellow, Titanium White and a little Bright Green, paint the top left area of the apple. Add into this mix Cadmium Red and a little Crimson, and fill in the apple shape. Make sure all your brush strokes follow the shape of the apple – this is most important.

Now, using the same colours but darker, paint the shadow areas on the apple. Add Ultramarine to your mix for the darkest ones. Finally, paint a background of Coeruleum and Titanium White and add a shadow to 'sit' the apple on the ground.

▼ I did this apple on Cryla paper, measuring 10 x 10 cm (4 x 4 in). Make sure you paint your brush strokes following the shape of the apple. This will help to make it look round.

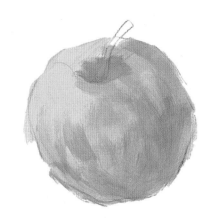

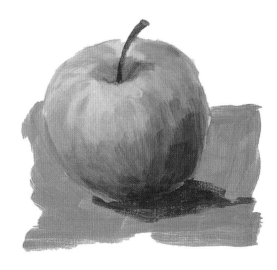

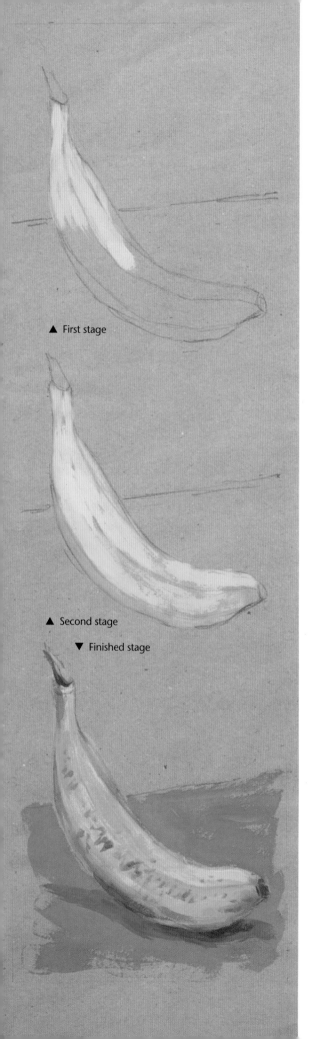

▲ First stage

▲ Second stage

▼ Finished stage

Paint a banana

Like the apple, a banana doesn't need a lot of drawing skills, so you can concentrate on the painting. Work it simply and without detail – as you gain confidence through practice, you will find that detail will come as a natural progression. I painted this banana on brown wrapping paper, measuring 12.5 x 12.5 cm (5 x 5 in). You will find that brown wrapping paper varies a lot in colour and thickness but you can paint on most types.

First stage
Draw the banana with your 2B pencil. Then, with a mix of Cadmium Yellow and Titanium White, and your No. 10 Cryla brush, start at the top and paint down the banana.

Second stage
Continue working down but add Raw Sienna to your mix to darken the colour.

Finished stage
Add Cadmium Red and a little Ultramarine to your mix and paint the darker shadow areas. Using your No. 6 round brush, paint in the two ends and the dark markings on the banana. Finish by painting in the background with a mix of Ultramarine and a little Titanium White. The shadow has less white paint added.

▼ This sketch was done on brown wrapping paper, 28 x 35 cm (11 x 14 in). I did it on location at an Art Materials Show in London. Notice how I have left the brown paper showing through in places. This helps to give colour unity to the sketch.

▲ First stage

▲ Second stage

▲ Third stage

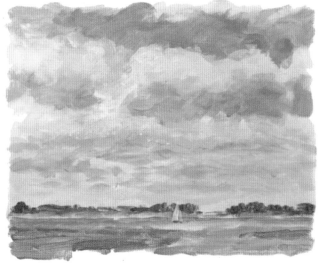

▲ Finished stage

Paint a sky

I did this sky exercise on Cryla paper, measuring 12.5 x 15 cm (5 x 6 in). It's more complicated than the banana or apple, so look at each stage carefully to make yourself familiar with the picture. You won't be able to copy mine exactly – use it as a guide.

First stage

Paint in the main blue areas of sky. Mix a little Titanium White with Ultramarine and use your No. 8 Cryla brush. Working your brush strokes in the direction that the clouds are moving, from left to right, will give movement, even at this very early stage.

Second stage

Now start to paint in the clouds. Use the same brush, with a mix of Raw Sienna and Titanium White. Add a little Crimson and more Titanium White for the lower clouds,

making your brush strokes smaller. This helps to show distance. Paint over the blue sky areas in places – this gives more depth to the sky.

Third stage

Continue to paint the clouds to the horizon. As you work down, add a little more Crimson and Titanium White to the mix. Then, with a mix of Ultramarine, Raw Sienna, Crimson and a little Titanium White, paint in the cloud shadows. Don't be too precise with the shapes – let the shadows go over the blue sky in places.

Finished stage

Refine the shadows by adding Titanium White to the dark paint. Work it from the shadows into the lighter parts of the clouds. Add Titanium White to the yellow mix of the clouds and work this into the dark areas. Now add the dark clouds, going down to the horizon with horizontal brush strokes. Finally, suggest the land to give scale to the sky.

Trees – oil technique

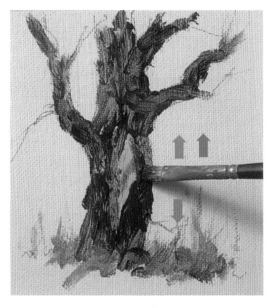

▶ When painting a tree in the foreground of your picture, use Cryla Colour (the thick paint) and work the brush up and down to give the impression of bark.

Trees really inspire me. Perhaps it's because you can be more relaxed about drawing them than, say, boats or buildings! If a branch is drawn too high or at a slightly different angle to the tree you are copying, it won't spoil your painting, but if a yacht mast or a window frame is drawn incorrectly, it will look wrong in your picture – especially to a boat builder or an architect! Perhaps I have exaggerated the point – there are, of course, ways of drawing a tree badly, even with incorrectly drawn branches.

The first and most important rule to remember is to draw or paint your brush strokes in the direction that the tree grows. Start with the trunk and work up and outwards to the small branches. As you progress up the tree, you must change your brushes to suit the thickness of the branches. It is very important to have a gradual progression from thick trunk to thin branches. This is a second golden rule.

I suggest you begin by drawing trees in pencil to observe their shape and structure, before you start painting them. It is also a good idea to concentrate on one type of tree (a winter tree is easiest) until you gain more confidence.

I did the exercises *(right)* on canvas boards measuring 10 x 10 cm (4 x 4 in). The detail *(above)* was taken from one of my paintings worked using the oil technique.

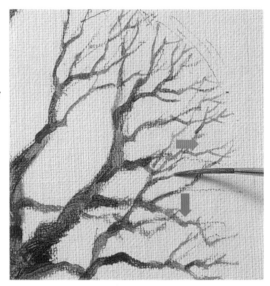

▶ Use your 'Rigger' brush to paint the thin branches and work in the direction that they grow. Remember to use enough water to allow the paint to run easily from your brush.

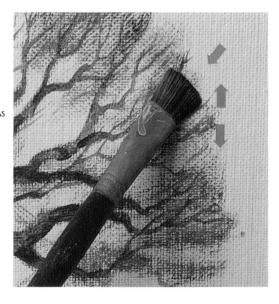

▶ When you paint the 'feathery' branches on trees, use a dry brush technique (see page 17). At the top of the tree drag your brush down – this gives a controlled shape. As you come down the tree, always take the brush in the direction the branches are growing.

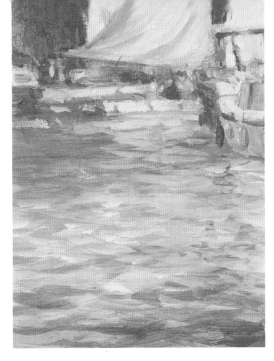

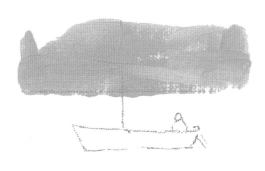

▶ Draw in the boat with a 2B pencil. Next, paint the sky using a mix of Titanium White, Ultramarine and a little Crimson.

Water – oil technique

The close-up detail *(above)* is from my painting on page 9. I find that people are always intrigued by water in a painting. If it is painted well and looks realistic, it will almost certainly attract compliments and provide a talking point. As with trees, there are a few simple 'rules' to learn. After that, personal experience gained from observing and painting water will enable you to progress.

Firstly, water must always look level on your paper, especially the horizon looking out to sea. Otherwise, the illusion of water will be lost because it will appear as if the water is running off the paper!

One of the simplest ways to create the illusion of water, is to put a reflection in it. The exercise *(right)* and the one on page 39 both show how easily this can be done. A simple reflection immediately gives the impression of water and this is the second rule for you to remember.

The third rule – it isn't what you put in, it's what you leave out that counts – applies to painting in general but to water in particular. It is one of the hardest rules to master for everyone, including me! Always remember, don't overwork your water. If you're in any doubt, leave it out.

The stages on this page were done on canvas boards, 10 x 10 cm (4 x 4 in).

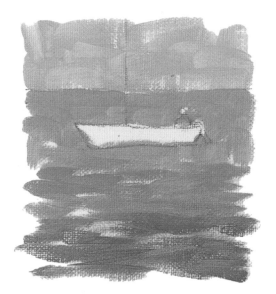

▶ Add more Ultramarine to your mix and work downwards with horizontal brush strokes. Don't paint over the boat. As you get nearer to the bottom of the picture, mix a little Bright Green with your colour. This will help to bring the water closer to the foreground.

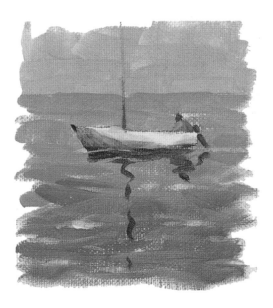

▶ Paint the shadow on the boat, the mast and the figure. Now you can add the simple reflection with your No. 6 round sable brush, using watery dark paint. Finally, with the same brush and a mix of Titanium White and a little Bright Green, paint in the reflected highlights on the water.

Watercolour Technique

As acrylic colours have increased in popularity, more and more artists have started painting with them with a watercolour technique. This isn't surprising, since they are water-based paints. If you already paint in watercolour, you will be very familiar with what I teach on the following pages. If not, I will explain enough for you to work in acrylics using a watercolour technique.

When acrylic paint is wet (very watery), the colours will run and blend into each other. But when dry, they will not mix. If you want a clean edge, your paint must be dry before you paint over it.

However, if you would like to learn more, I suggest you read my book, *Alwyn Crawshaw's Watercolour Painting Course*.

One main difference between using acrylics in a watercolour technique, rather than an oil technique, is that you don't use white paint to make the colours paler. Another important difference is that you work from light to dark as you paint your picture. Since the paint becomes transparent when you add water to it, you can't cover over a dark area with a lighter colour. Therefore, you have to build up your dark areas by painting darker tones over lighter tones when they are dry. Your light areas in a painting are left either as white, unpainted paper, or simply as lighter tones that have not been made darker by adding more paint on top.

Learning to paint a wash on to paper is the most important lesson in watercolour.

▲ **A Watery Sunlight**
acrylic watercolour technique, Waterford watercolour paper 300 lb Rough
50 x 75 cm (20 x 30 in)

A wash can cover all your paper, or be an area the size of a small coin. The paper must always be at an angle when you work – not flat – and the paint must be allowed to run very slowly down the paper. Some artists use an easel and have the paper upright. This is fine for those who work freely, accepting that the paint can run out of control down the paper at any time during a painting. However, before you are ready to try the upright position, you must learn how to apply and control paint.

Flat Wash

For a flat wash, mix plenty of watery paint in your palette and load your brush. Start at the top left-hand side of the paper if you are right-handed, taking the brush along in a definite stroke. Don't rush or panic. When you reach the end, lift the brush off the paper, bring it back to the beginning and start another stroke, running it into the bottom of the first wet stroke. Add more paint to your brush as you need it; don't let it get dry.

Because you mix the paint first and don't add any more water or paint to the mix, the colour remains the same throughout the wash. When it is dry, the colour density should look the same all the way down.

Graded Wash

For a graded wash, start as you did for the flat wash but, as you paint down, add more clean water to the paint in your palette for each brush stroke. This will make the colour weaker and, as you work down, the wash will grow gradually lighter in colour until, if you keep adding water and your paper is long enough, it will finish up as white as the paper you're working on.

Wet-on-Wet

As with watercolours, you can paint wet paint into wet paint with acrylics, using different colours. I use this frequently for cloudy skies because the colours blend together in a very soft and delicate way.

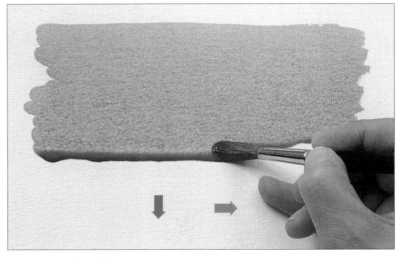

▲ Applying a flat wash

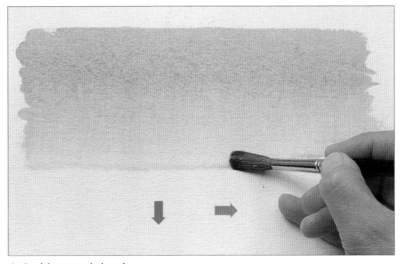

▲ Applying a graded wash

▲ Paint applied wet-on-wet

31

Wash-over-wash technique

In watercolour painting, an accepted technique is to paint wash-over-wash, which gives a depth to your painting. This can sometimes be difficult when painting in watercolour, as the underneath washes can be disturbed and mix with the new wash.

The beauty of acrylic colours is that this will not happen. Once an acrylic wash has been applied to the paper, and is dry, it becomes 'waterproof'. Therefore, you can paint another wash over the top without disturbing the one underneath and use washes to build up depth and strength in your colours.

Naturally, because of this you can't work over a pre-painted, dry colour to make it mix with the colour you are applying, as you can with watercolour. But then acrylics has its own compensations. You can't make your paintings muddy by overworking an area of a picture and picking up other previously painted colours, which can sometimes mix together to make a dirty colour. If you have worked in watercolour, you will know exactly what I mean!

In the example *(right)*, I have painted wash-over-wash to show how the paint gets darker as you apply each wash. The paint was the same colour used throughout.

◀ These washes were painted one over the other, when each one was dry, and the same watery blue wash was used throughout. You will see that because the paint was transparent, the depth of colour and tone increased with each progressive wash.

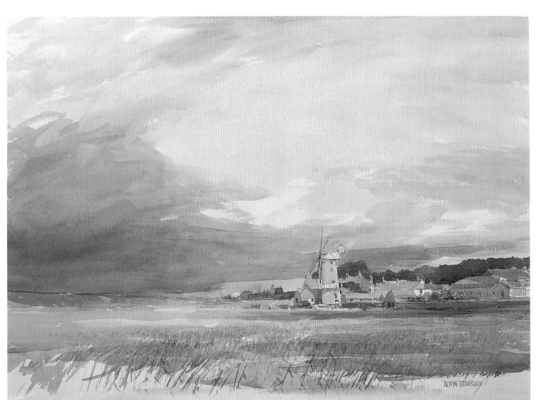

◀ **Cley Mill, Norfolk**
acrylic watercolour technique on Waterford watercolour paper 300 lb Rough
50 x 75 cm (20 x 30 in)
For both the sky and the foreground in this painting I used a wash-over-wash technique.

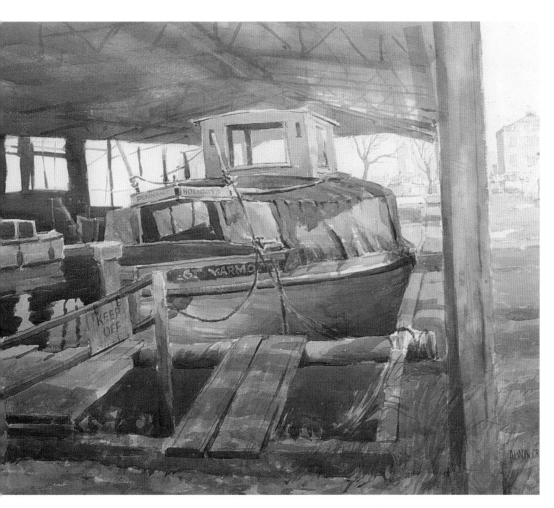

Choosing a surface

When using the watercolour technique, you can use any watercolour paper to work on without priming it. I like to work on Waterford watercolour paper Rough 300 lb but do try other surfaces. You will find, by experimenting, which ones you prefer.

Mixing techniques

When you are painting with acrylics, you can use as many oil and watercolour techniques as you like in one picture. In fact, this is one of the wonderful things about acrylic painting. You can work transparently, opaquely, and apply thick impasto work all on the same painting. But for a purely watercolour effect, remember to use only transparent paint, mixing your colours with plenty of water but no white paint.

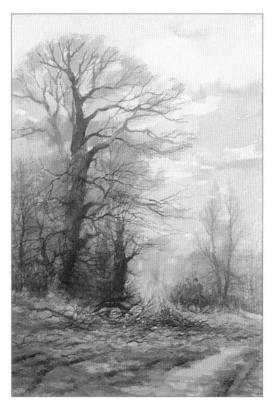

◀ **Trees (detail)**
acrylic watercolour technique on Waterford watercolour paper 300 lb Rough
50 x 35 cm (20 x 14 in) The fire in the picture was painted from light to dark using a normal watercolour technique. Compare this to the fire on page 22, which I did using Glaze Medium and an oil technique. That fire was achieved by painting lighter colours on darker ones, and the smoke was done using transparent colour over the dark background.

Simple Exercises

Try these watercolour technique exercises in any order you wish, but don't forget to put your white paint away, remember to use plenty of water and have your board at an angle.

Paint tomatoes

I painted these tomatoes on Waterford watercolour paper 300 lb Rough, measuring 12.5 x 10 cm (5 x 4 in).

First stage

Using your No. 6 round brush, paint in the shapes of the tomatoes using Cadmium Red and a little Crimson for the darker areas. Remember to use water to make the paint lighter. Add the stalk with Cadmium Yellow and a little Bright Green.

Finished stage

Work over the tomatoes again making them darker on the shadow side. Darken the stalk in places and paint in the watery Ultramarine background. Notice how I left some unpainted white paper showing – this gives life to the background.

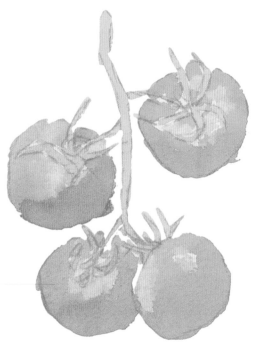

▲ First stage

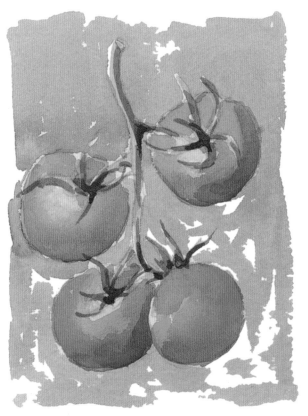

▲ Finished stage

▲ First stage

▲ Second stage

▲ Third stage

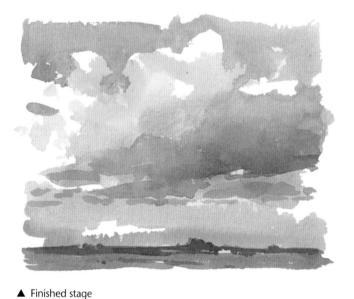

▲ Finished stage

Paint a sky

When you painted the sky on page 27, I told you to use my painting as a guide. This applies to all these watercolour technique exercises as well. For this sky, I used Waterford watercolour paper 300 lb Rough and my No. 10 round brush. I worked the painting twice the size it is shown here.

First stage

To paint the clouds, mix a little Cadmium Yellow, Raw Sienna, Crimson and Ultramarine. Start at the top of your paper and work down. Remember to keep your paint watery, or the colours won't blend together to create a soft cloud-like effect.

Second stage

Now paint the blue sky with Ultramarine and Crimson and let it run into the wet clouds in places.

Third stage

When this is dry, paint the blue sky below the clouds. Put in the darker cloud shadows by painting some water towards the top of each cloud, then adding darker colour to it and working downwards. The resulting effect will be to give a soft edge to the cloud where the light colour goes into the dark colour.

Finished stage

Finally, paint the landscape and put more dark colour on the main cloud.

Paint a fish

I painted this mackerel on Waterford watercolour paper 300 lb Rough, measuring 5 x 17 cm (2 x 7 in).

First stage
Use plenty of water to allow your colours to mix (wet-on-wet). Starting with the head of the fish, work down it to the tail, using your No. 6 round brush and a mix of Cadmium Yellow, Cadmium Red, Ultramarine and a little Crimson. Remember to leave some white paper unpainted.

Second stage
Now put a pale green wash mixed from Cadmium Yellow and a touch of Bright Green over the body. Where this goes over the white paper it will look shiny, and where it covers the first stage wash it will give more variation to the colours and make them darker. Add a little more work to the head.

Finished stage
Paint a dark edge to the top edge of the fish, put more detail into the head and paint the eye. The result of your painting will rely on the way your colours mix together. When things go well in areas of uncontrolled painting, artists call it a 'happy accident'. It is an exciting way to paint, so good luck with it.

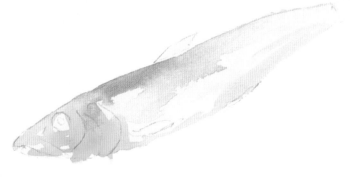

▲ First stage

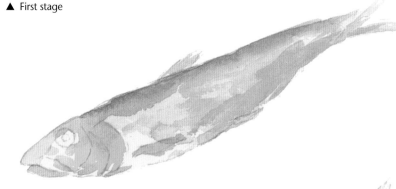

▲ Second stage

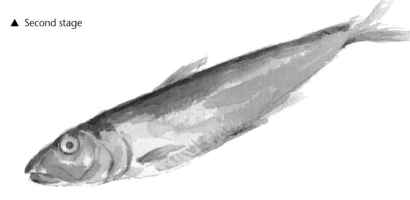

▲ Finished stage

Paint a lemon

This was done on Waterford watercolour paper, 300 lb Rough, 10 x 10 cm (4 x 4 in).

First stage
Paint in the middle of the lemon with a No. 6 round brush and a watery mix of Cadmium Yellow, Crimson and Ultramarine. Leave some white paper unpainted for the segments.

Second stage
Paint the lemon peel with Cadmium Yellow.

Third stage
Use a darker wash than in the previous stage to paint over the segments of the lemon. Paint a pale yellow 'line' around the thickness of the skin.

Finished stage
Add more darks to the lemon. Then put in the background to the picture, using a mix of Bright Green and Cadmium Yellow to start with and then adding Coeruleum as you work to the bottom. When this is dry, add the shadow.

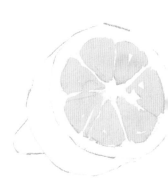

▲ First stage

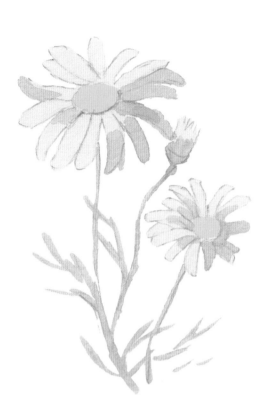

▲ First stage

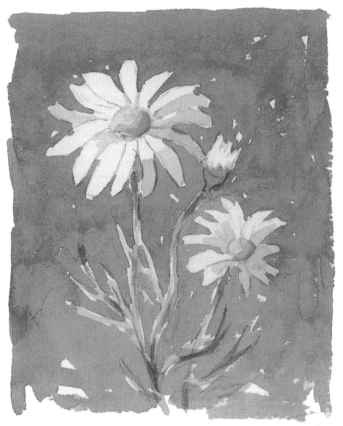

▲ Finished stage

Paint flowers

I did these daisies on Waterford watercolour paper 300 lb Rough, 12.5 x 10 cm (5 x 4 in).

First stage

With your No. 6 round brush and a mix of Ultramarine and Crimson, start by painting in the shadows on the petals. Work the leaves and stems with Bright Green. Then paint in the yellow centre of the flower.

Finished stage

Paint in the background with Ultramarine, adding water to make it lighter as you work to the bottom (graded wash). Finally, add some darks to give a little more detail to the flower and the leaves.

▲ Second stage

▲ Third stage

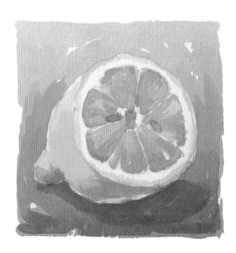

▲ Finished stage

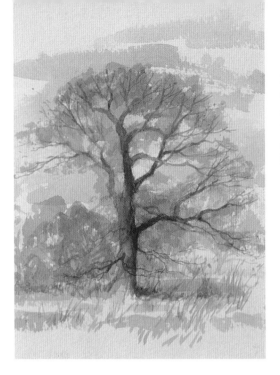

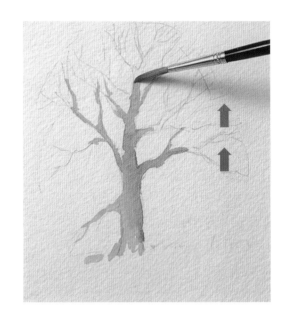

▶ Use plenty of water with your paint and work up the tree using your No. 6 round brush, but don't try to paint any thin branches with it.

Trees – watercolour technique

Most of the 'rules' that apply to painting trees in an oil technique are the same as those for painting them in a watercolour technique (see page 28).

The only additional thing that you must remember is that you are working from light to dark and you can't paint anything lighter over a darker painted area. If you look at the finished stage on this page you will see that the sunlight on the trunk was achieved by painting the sunlit area first. Then the darker areas were painted over this, leaving the light areas to give the impression of sunlight.

It is always a good idea to show something in the same picture as a tree to give some idea of scale. Of course, if you paint a tree in a full landscape, there will be plenty of objects around the tree to help the viewer appreciate its size. But a tree by itself, even in a quick sketch, needs something to show the viewer how tall it is. In my exercise, I have suggested a fence post and I did this with a single brush stroke. Although a very simple device, it is enough to suggest the size of the tree.

The stages on this page were done on Waterford watercolour paper 300 lb Rough, measuring 15 x 12.5 cm (6 x 5 in).

▶ Continue working the branches but change your brush to a 'Rigger', with which you can paint even the thinnest branches. Remember, your brush strokes must go in the direction the branches grow.

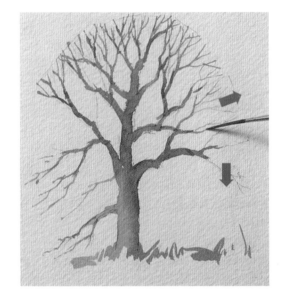

▶ For the feathery branches, load your brush with watery paint and drag it over the dry, already painted branches. Lift the brush occasionally as you drag it over and you will get a broken effect. This example is of a winter tree. If you want to paint one in leaf, use the same technique but use a green mix for the foliage.

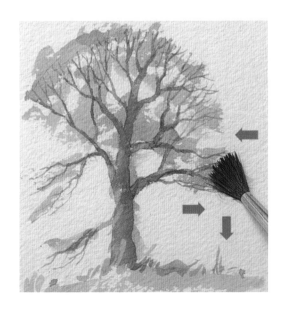

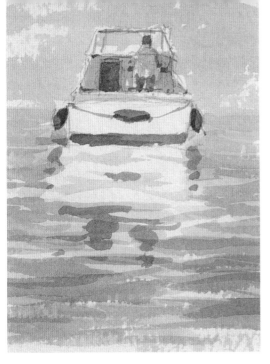

▶ Again use plenty of water. Mix a wash of Ultramarine and a little Crimson. Start at the top using a No. 6 round brush, and paint down with horizontal brush strokes, leaving white areas of paper to represent reflected light on the water. Remember, when painting water, keep things simple.

Water – watercolour technique

Since you work from light to dark with a watercolour technique, all the reflected light on the water you are painting must be left as unpainted white paper. As I have said before, it is wise to leave more out than less. You can always put another tone over the white paper if you find you have left too much paper unpainted. Read the oil technique rules for painting water (on page 29) again, since these apply to the watercolour technique, too.

Finally, here's a very important rule which applies to water, and whatever else you might be painting. At first, it sounds rather silly but, believe me, it does work. It really will help you to paint better if you let this discipline become second nature to you.

Try to think yourself into the very essence of what you are painting. When you are painting clouds, say to yourself, 'I'm a cloud', and imagine that you are floating through the sky. Let your brush go with that idea, painting in a gentle 'cloud-like' manner. If you were painting steam engines, your brush would work very hard and in a positive manner. In this case saying, 'I'm water', should get your brush reacting in a gentle, rippling, watery way.

The stages on this page were done on Waterford watercolour paper 300 lb Rough, measuring 15 x 12.5 cm (6 x 5 in).

▶ With a darker mix, and adding a little Cadmium Yellow, paint some more 'wave' brush strokes over your original wash.

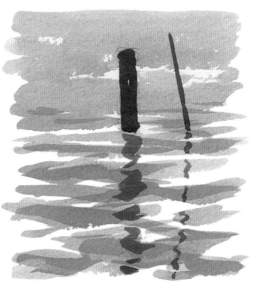

▶ Paint in the two posts and add their reflections. You can see how simple reflections help to give the illusion of water.

Hedgerow Poppies

There are few things more breathtaking than a hedgerow full of bright red poppies. If you attempt to paint a mass of them, the result can look rather artificial, so beware. It is better to choose a small section and concentrate on painting just a few close-up blooms. As the predominant colours – red and green – are complementary, your painting will be vibrant.

▶ First stage

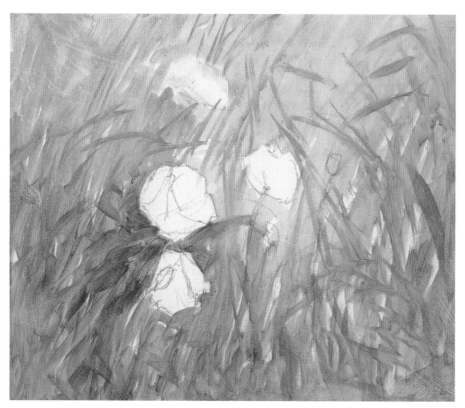

Colours

 Bright Green

 Cadmium Yellow

 Ultramarine

 Crimson

 Cadmium Red

 Titanium White

First Stage

I started by drawing in the four main poppies and some of the poppy buds with my HB pencil. Then I sketched in an impression of the grasses which form an 'archway' over the poppies with free pencil strokes. I didn't attempt to draw the individual blades of grass because these would be done with my brush.

Next, using my No. 10 Cryla brush and a mixture of Bright Green, Cadmium Yellow, Ultramarine and a little Crimson, I painted in the grasses. I used a watercolour technique for this, letting the brush strokes suggest the grasses.

It would be impossible for you to copy my grasses because of the free way in which they were done, but do make sure that the grasses in your painting form an archway, and that the brightest area of colour is behind and above the poppies.

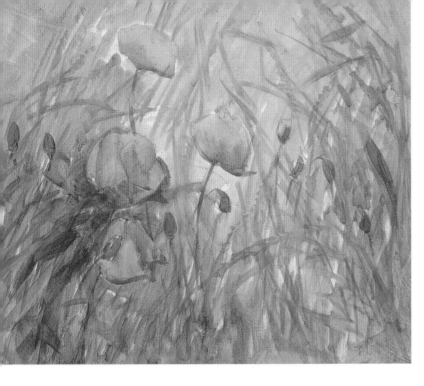

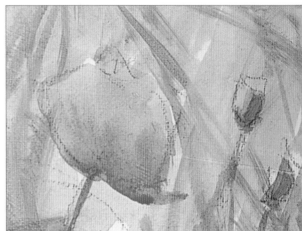

◀ Second stage

▼ Detail from second stage, reproduced actual size

Second Stage

The next two stages were painted with a No. 6 round brush. I continued to use a watercolour technique to paint in the poppies, mixing Cadmium Red and a little Crimson for the darker areas and adding a little Cadmium Yellow for the more orange-coloured ones. Remember, use your paint more watery to make the colours paler.

Next I suggested the poppy behind the grasses on the right of the painting and then painted in the buds and some more grasses, using the grass colours for both.

Finally, I painted in the stems of the poppies. When you do these, paint them carefully because they are an important feature of the painting.

Third Stage

From this stage onwards, I used Titanium White and thick paint and worked in an oil painting technique.

I started by painting the poppies, adding a little Titanium White to my mix for the lighter petals, and a little Ultramarine for the dark areas. I was careful not to overwork the poppies, as I wanted them to look delicate.

I painted in some more darks around the lower two poppies, taking my brush strokes in the direction of the grasses. I didn't cover all the underpainting but left some showing to give depth to the painting. I also added some more light and dark grasses but didn't paint any over the two central poppies.

I kept the background to the centre right-hand poppy simple and bright, and also painted in the dark centre of the bloom to the left of it, giving that one dimension and form.

▼ Third stage

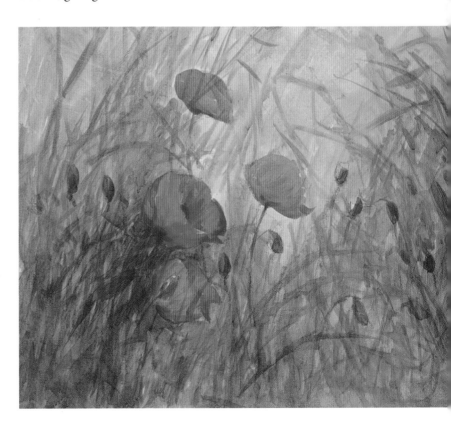

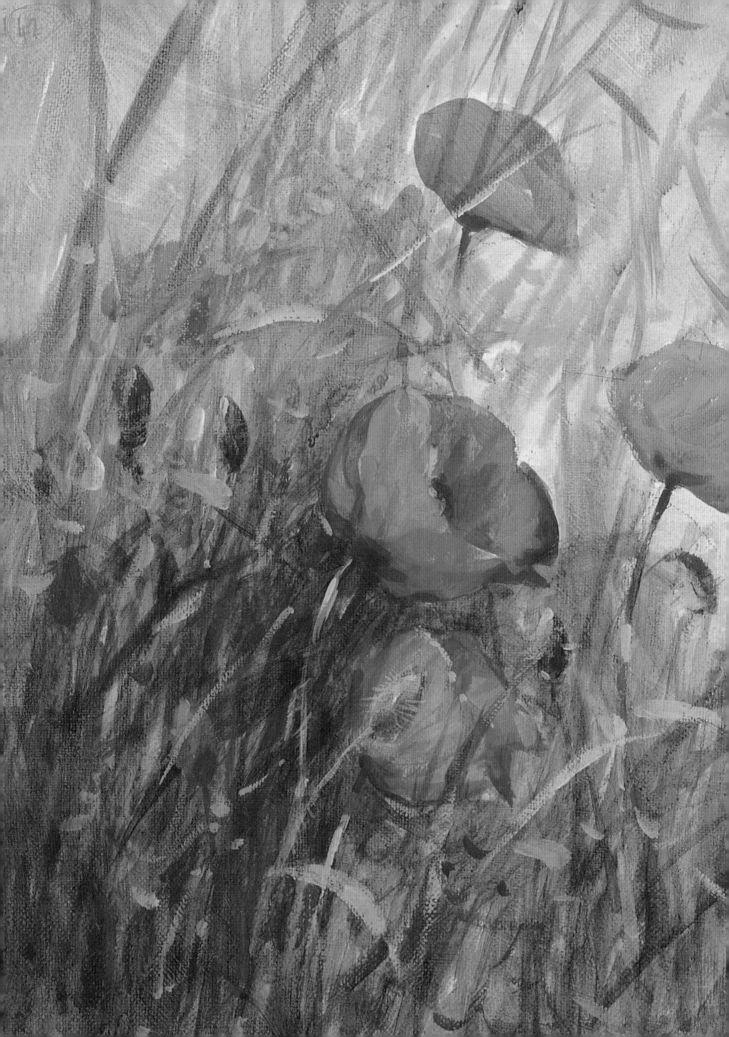

Finished Stage

At this stage, I painted a suggestion of single poppies behind the grasses on the left and right of the painting. I had purposely left these out until the end because I wasn't sure whether I would need any more red in the picture. But I now felt it would help the painting and add depth through the grasses. Also, because of the bright area behind the poppies and the archway made by the grasses, your eye is taken through the painting into that mysterious, sunlit area.

I added some highlights to some of the petal edges but made sure I didn't overdo these. Then, with a very light green, I painted in some more grasses, very carefully putting one over the top poppy. This had the effect of positioning it further into the grasses. I also painted the stems dark under the poppies.

◀ **Hedgerow Poppies**
acrylic oil technique on canvas
25 x 28 cm (10 x 12 in)

Norfolk Pheasant

We found this pheasant living at the bottom of our garden in Norfolk. I just had to paint him – his colours are absolutely incredible, especially close-up. I left the background behind his head plain and uncluttered – this helps to make him the centre of interest.

▶ First stage

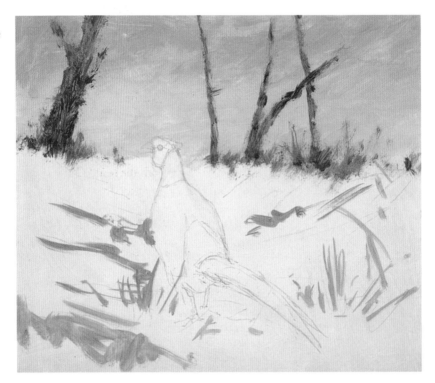

Colours

Ultramarine

Crimson

Bright Green

Raw Umber

Raw Sienna

Cadmium Red

Cadmium Yellow

Titanium White

First Stage

I established the line under the trees and drew in their trunks with HB pencil. Then I drew the pheasant. I painted in the sky using my No. 10 Cryla brush, starting with Titanium White, Ultramarine and Crimson, adding more Titanium White as I worked down. I added a little Bright Green to paint over my drawing of the trees. Then I painted the trees with my No. 4 Cryla brush and Cryla Colour (the thick paint) in a mix of Raw Umber and Bright Green, also suggesting the start of the hedge. I put in some free contour lines to show the form of the ground with a watery mix of the same colour.

Second Stage

I added more branches to the trees and painted in the feathery ones. Then I used my No. 10 Cryla brush and a watery mix of Raw Sienna, Bright Green, Crimson and Ultramarine to scumble in the foreground. The painted lines from the first stage still show through, helping to give depth and movement. I added ground shadows, then painted in the bird with my No. 6 round brush. I used a watery mix of Cadmium Red and Crimson for the head, Ultramarine, Bright Green and Crimson for the neck and a mix of Raw Sienna, Cadmium Yellow, Crimson and Ultramarine for the body.

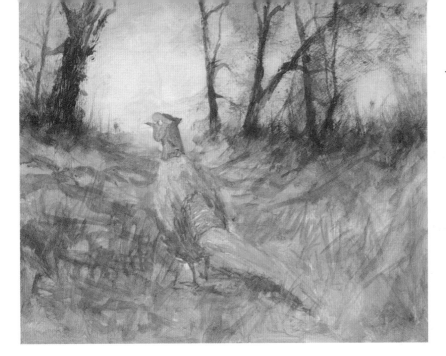

◄ Second stage

Finished Stage

I used the same colour mixes to go over the pheasant again, adding Titanium White to lighten or give more body. I painted the eye and the beak carefully – these are both important. Then I painted in more grasses with my No. 6 round brush, making some brighter by adding Titanium White to my colours. These highlights help to give the illusion of sunshine. I also painted some grasses over the bird. If you have problems painting the pheasant, remember you can work over and over until you are happy with the result. This is one of the great advantages of acrylics.

▼ **Norfolk Pheasant**
acrylic oil technique on primed hardboard
25 x 28 cm (10 x 12 in)

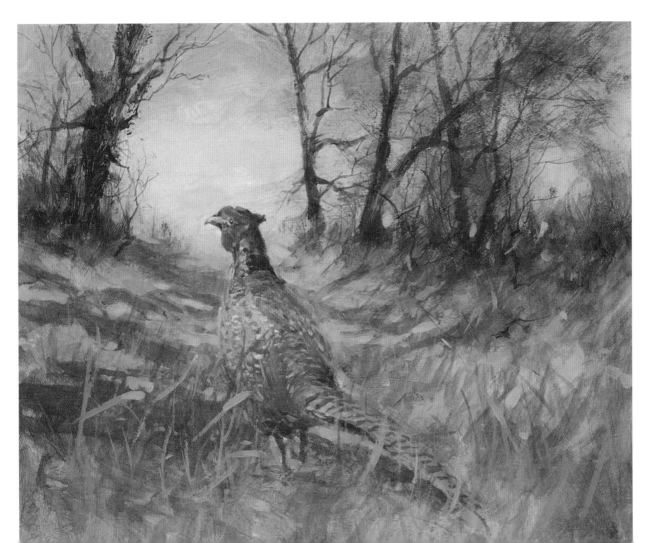

Evening Landscape

This painting is of a typical countryside scene. It has a happy and restful composition, with the country path leading the viewer into the picture. Once the path has gone round and behind that tree, the viewer must use his or her imagination as to where it will lead! The evening sky also gives the painting a peaceful atmosphere.

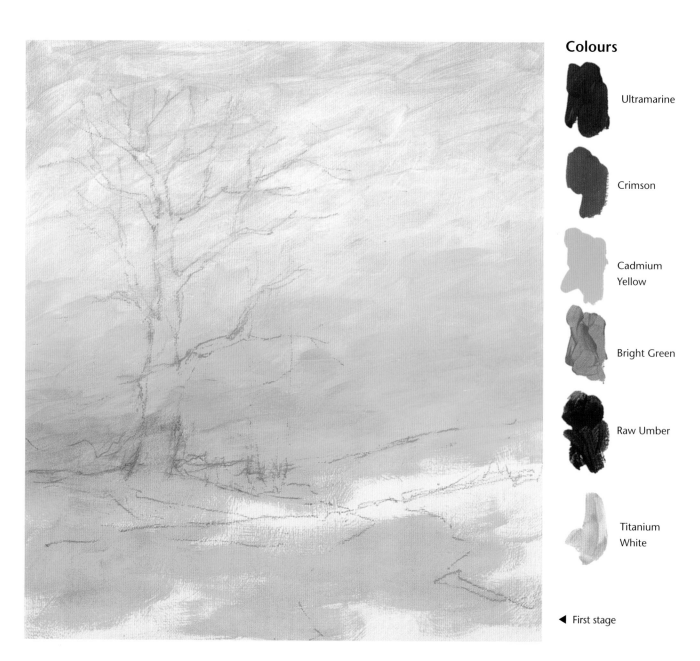

Colours

Ultramarine

Crimson

Cadmium Yellow

Bright Green

Raw Umber

Titanium White

◄ First stage

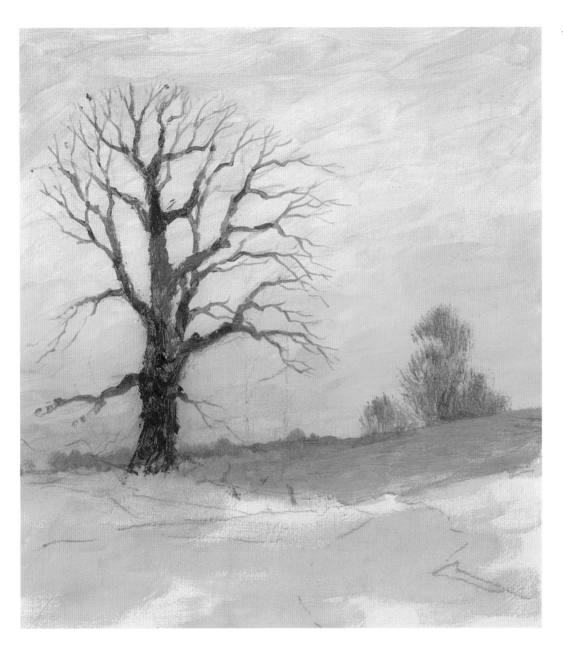

First Stage

I drew the scene with HB pencil but didn't put in any detail. Then, with my No. 10 Cryla brush and a mix of Titanium White, Ultramarine and a little Crimson, I painted the sky. I started at the top and worked down, adding more Titanium White and Crimson as I went. I added Cadmium Yellow and more Crimson to the mix to paint over the horizon and into the foreground. This foreground colour would be left to represent the puddles on the path. Notice how I painted over my pencil lines – when your paint is not too thick, these will show through, so you won't lose your drawing!

Second Stage

I painted in the distant hills with my No. 4 Bristlewhite brush and a mix of Ultramarine, Crimson and Titanium White. For the field in the middle distance, I used a mix of Titanium White, Cadmium Yellow, Crimson and Bright Green. I painted in the main tree trunk with Cryla Colour (a mix of Raw Umber and Bright Green), adding a little Crimson and Ultramarine. Then I changed to my No. 6 round brush and my 'Rigger' to work the smaller branches. I painted in the trees in the middle distance with the dry brush technique used for the feathery branches on page 28.

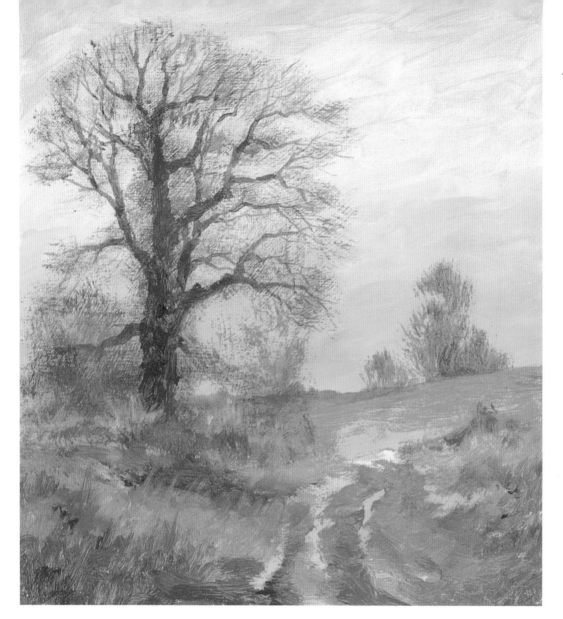

◀ Third stage

Third Stage

I painted in the feathery branches of the main tree with my No. 8 Bristlewhite brush, also suggesting some branches on each side of the main trunk. I painted the hedge, then the foreground with my No. 4 Bristlewhite brush and a varying mix of Titanium White, Bright Green, Raw Umber, Cadmium Yellow, Ultramarine and Crimson. I added Texture Paste in places as I worked to get a more impasto effect, especially on the path. I left the underpainted sky colour to represent the puddles. I worked my brush in up and down strokes to represent grass, and horizontal strokes for the path and the flat areas.

Painting the foreground in this way produces many 'happy accidents', so use them to their best advantage.

Finished Stage

I used my No. 6 round brush to finish painting the main tree and also to add some small trunks and branches to the feathery branches on the right of the main tree.

When you get to this stage in your painting, look at the path and foreground and add as much detail and modelling as you feel will help your picture. However, be very careful not to overdo things – always let some of your original brush strokes be part of the finished painting.

Finally, I painted in the last bit of sunlit cloud over the distant hills with my No. 6 round brush, using a mixture of Cadmium Yellow and Titanium White. I used the same brush to paint in the broken fence and, as a last touch, to paint in some flying birds.

▶ **Evening Landscape**
acrylic oil technique
on canvas
28 x 25 cm (12 x 10 in)

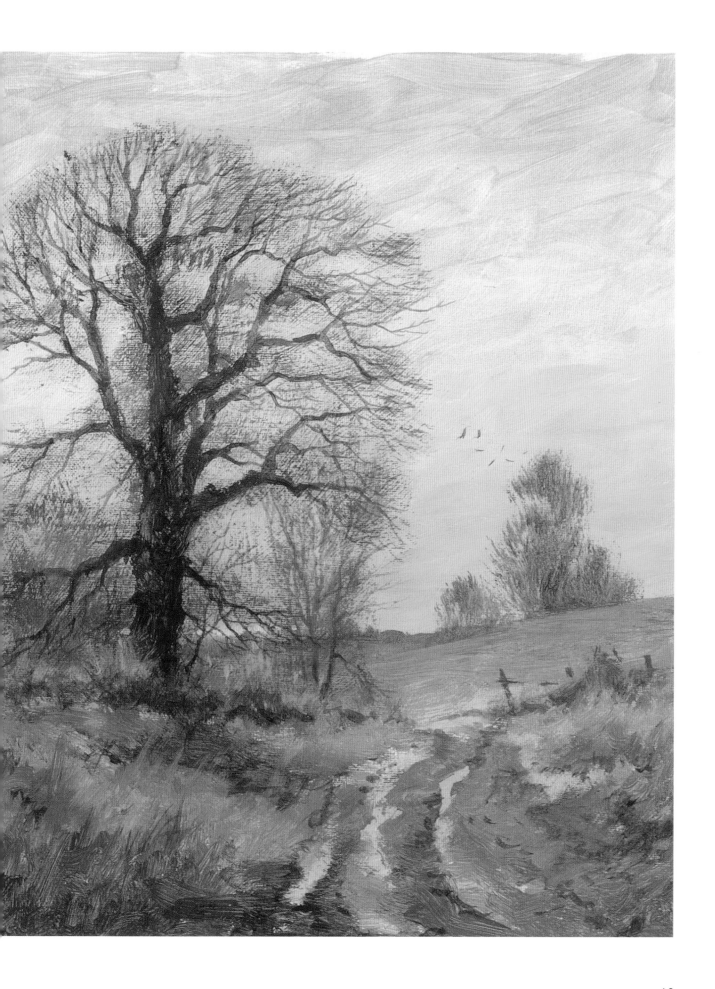

The Grand Canal, Venice

I did a pencil sketch of this view of the Grand Canal early one morning but didn't have time to paint it. However, just drawing it and enjoying the atmosphere was wonderful. I also took a photograph of the scene, to help me when I painted it at home.

First Stage

If you don't feel very confident about drawing buildings, leave this exercise until later. It's not for the faint-hearted but try it and enjoy it – you may surprise yourself!

I established the horizon first, then drew the buildings on either side of the canal, without putting in detail. Always make sure you're happy with a drawing before you start painting. I used my No. 12 Cryla brush to paint in the sky, using a mix of Ultramarine, Titanium White and a little Crimson. I added more Titanium White, Crimson and a little Cadmium Yellow as I went down to the horizon.

Second Stage

I started by painting the buildings on the right side of the canal with my No. 10 Cryla brush, using a watercolour technique and a varying mix of Cadmium Red, Cadmium Yellow, Raw Sienna, Crimson and Ultramarine. Working my brush strokes

Colours

Ultramarine

Crimson

Cadmium Yellow

Cadmium Red

Raw Sienna

Coeruleum

Bright Green

Titanium White

▼ First stage

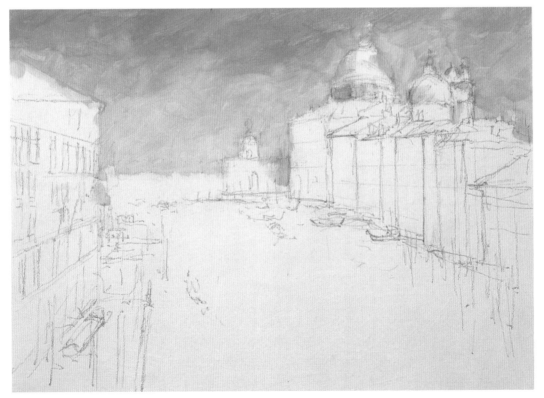

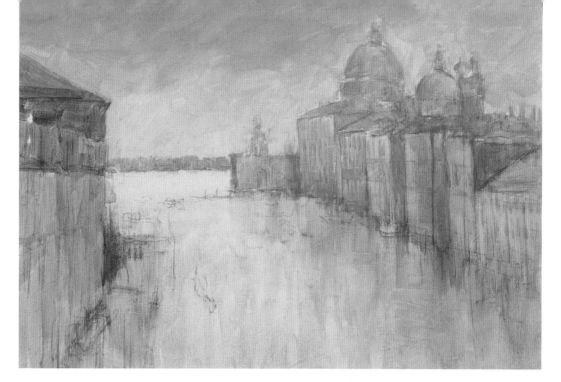

▶ Second stage

up and down helped to create the effect of buildings. I dragged the building colour into the canal as I painted to leave an under painting for the reflections of the buildings. I painted the buildings on the left of the canal, making the colours stronger because the buildings are in sunlight.

I used the same brush to suggest the distant buildings on the horizon. Then, with a mix of Coeruleum, Ultramarine, Cadmium Yellow and a little Titanium White, I painted in the water, adding some of the building colours which were left on my palette to put in more reflections. I used a watercolour technique for this and painted with downward brush strokes.

Third Stage

I used the paint thicker for this stage, working on the buildings with my No. 6 round brush. I added more darks the same colour as the buildings but made them stronger by adding more Ultramarine. Windows, some of the balcony, and the roof shadows were suggested with single brush strokes. I made the buildings darker nearer the water, where there was more activity and structure, and put more modelling into the buildings on the left-hand side of the picture, as these were nearer. I also suggested some balconies and windows, and painted some of the landing stages for boats.

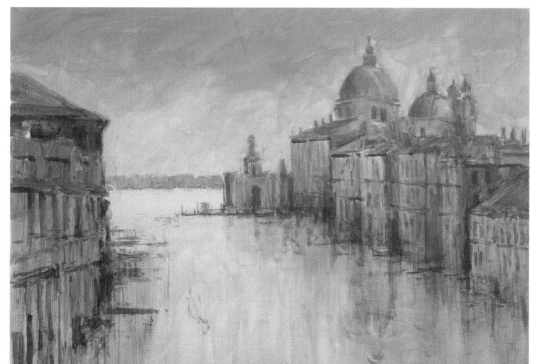

◀ Third stage

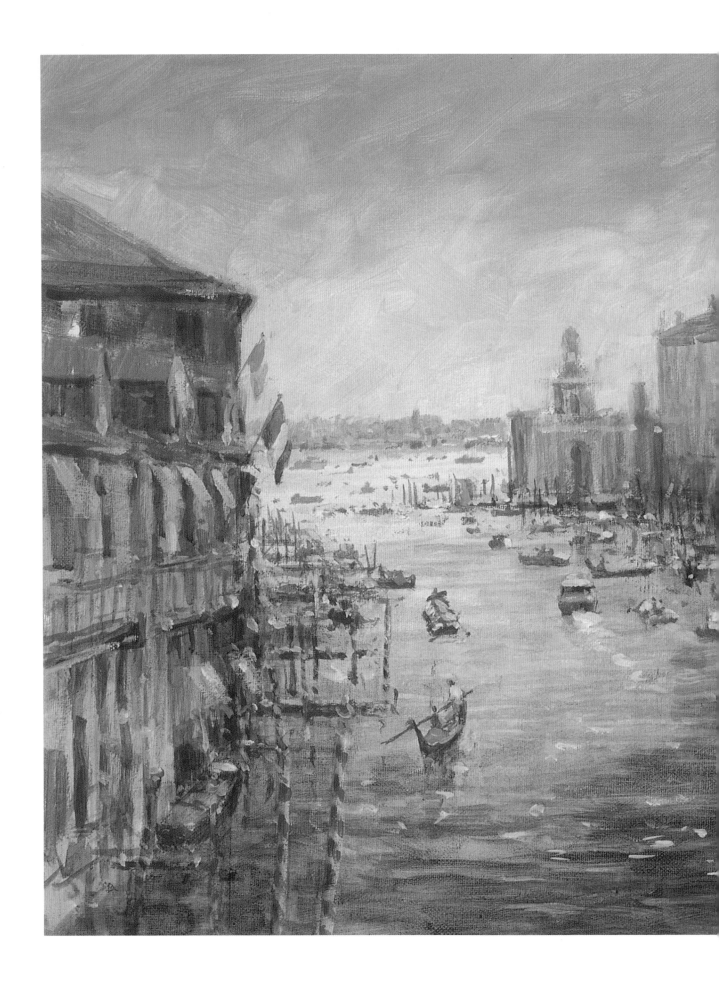

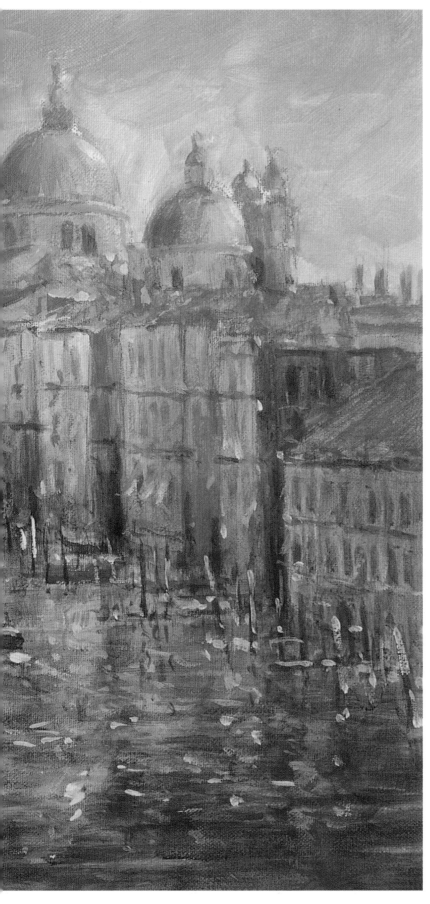

Finished Stage

I painted over the water again with my No. 6 round brush, using horizontal brush strokes to give the illusion of moving water. I used the same colours as before, but added some Bright Green. The boats were painted in with the same brush, working with dark colours. You will see that I changed the gondola from the first stage. I decided the position of the new one gave a happier feeling to the composition. Most of the boats in the distance were suggested with horizontal brush strokes – because there are boats in the foreground, the eye accepts that these little daubs of paint are boats, too.

Now I had reached the really exciting part! I used strong colours to paint the flags on the left of the picture and the posts in the left-hand corner. I also put in some blinds over the windows and added colour and highlights to a few boats. I painted out the near posts that had been at the bottom right. These were far too big and almost in the middle of the canal! Finally, using juicy thick paint, I painted in strong highlights on the buildings, the poles, the boats and the water. When you do it, just let the brush dance around and you will feel and see your painting come alive. Good luck!

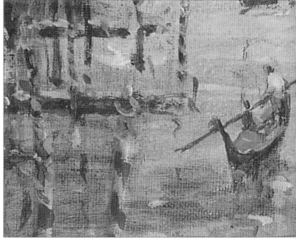

▲ Detail from finished stage, reproduced actual size

◀ **The Grand Canal, Venice**
acrylic oil technique on canvas
28 x 40 cm (12 x 16 in)

Spring Landscape

Here's a simple, colourful scene for you to try for your first watercolour technique painting in acrylics. It portrays a warm spring day with soft gentle clouds drifting across the sky. Relax and paint it very freely. Because it is painted in this way you won't be able to copy my picture exactly – so the 'happy accidents' will be all your own!

First Stage

I began by putting my white paint away! I drew in the picture with 2B pencil. Then, starting with the sky, I used my No. 10 round brush, plenty of water and a mix of Raw Sienna and Cadmium Yellow to paint in the top of the clouds. While this was still wet, I mixed Ultramarine and Crimson to paint into the yellow clouds with a wet-on-wet technique. Next, with a mix of Ultramarine and a little Crimson, I painted in the blue sky, leaving a white edge (unpainted paper) at the top of the clouds. I added more Crimson to the blue sky, underneath the clouds and towards the horizon. The sky was painted while all the paint was still wet.

Colours

Raw Sienna

Cadmium Yellow

Ultramarine

Crimson

Bright Green

▼ First stage

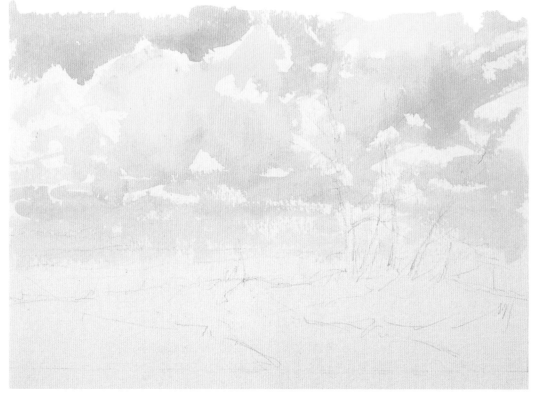

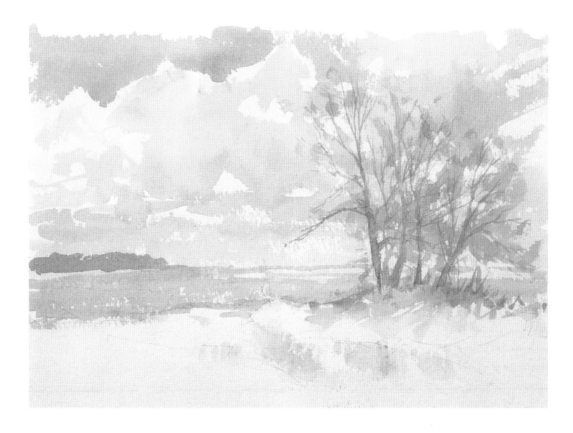

Second Stage

I painted in the distant hills with a mix of Ultramarine and Crimson, then worked down to the hedge with the fence, adding Cadmium Yellow and Bright Green. I let these colours run together, but not on to the base of the hills. Finally, I ran some colour under the trees. I used my No. 6 round brush and my 'Rigger' to paint in the trees, putting in the feathery branches with a mix of Bright Green and a touch of Raw Sienna. I added a little Crimson to this mixture for the middle of the trees. Then, with a weaker mix of the blue sky colour, I painted in the puddles on the path. I left the painting to dry before continuing to the next stage.

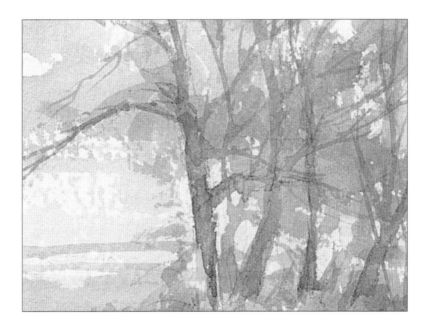

▶ Detail from the second stage, reproduced actual size

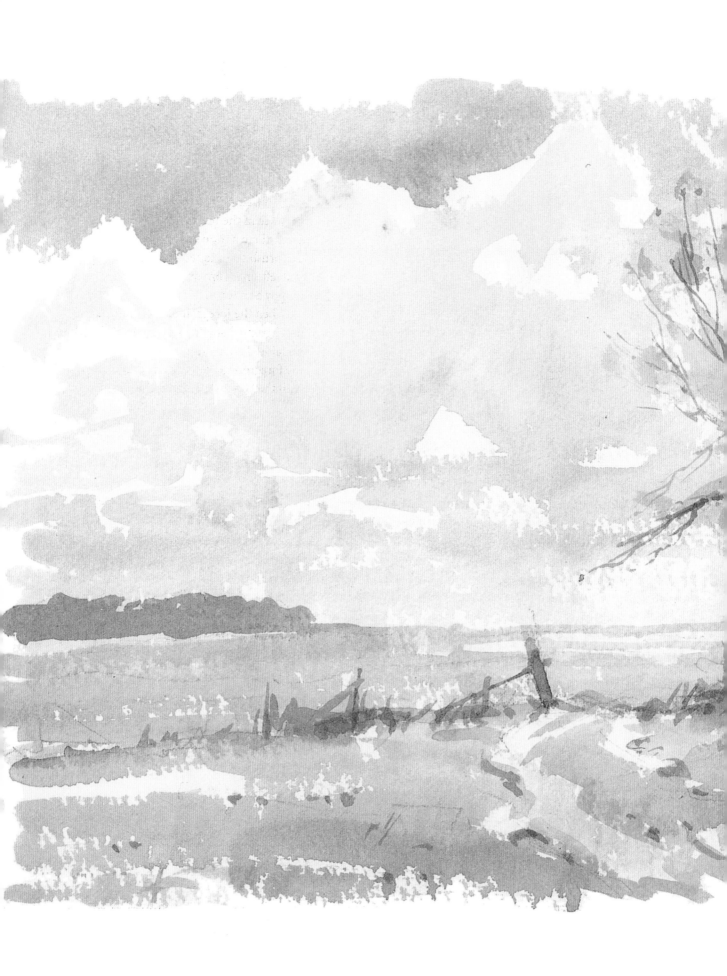

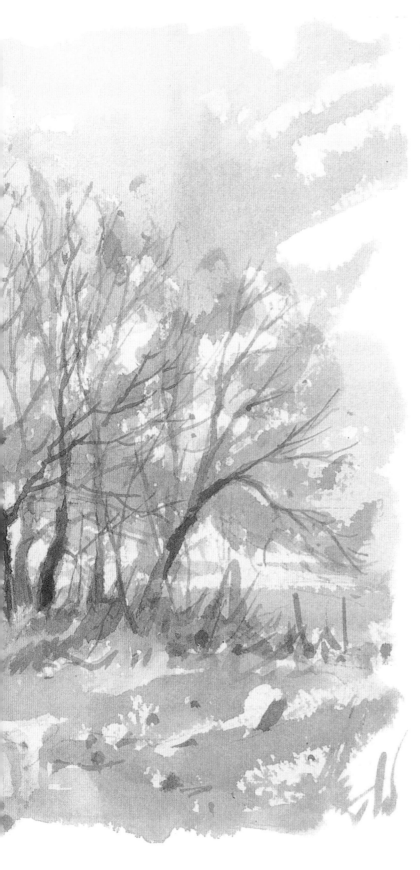

Finished Stage

I painted in the broken fence and the dark area to the left of the first tree trunk with my No. 6 round brush. This helped to establish the trunk and suggest sunlight on it (light against dark).

When I painted in the foreground, I used the same colours as I had for the middle distance in the previous stage, but this time made them a little stronger. For this, I used a dry brush technique in places (see page 17) and left small, unpainted white paper areas (happy accidents).

When the foreground was completely dry, I painted shadows on some of the white unpainted areas. This added dimension to the foreground. You can see this very clearly with the large stone under the tree.

◀ **Spring Landscape**
acrylic watercolour
technique on Waterford
watercolour paper
300 lb Rough
23 x 35 cm (9 x 14 in)

Winter Landscape

This winter landscape is quite a challenge because the snow is represented by white unpainted paper, except for the shadows, which have to be painted in freely but positively. I used the same sketch to work from as I did for my snow painting on page 9.

First Stage

I drew in the picture with my 2B pencil, leaving detail to be done with my brush as I progressed through the painting. I painted a wash over the whole sky with my No. 10 round brush and a mix of Cadmium Yellow, a touch of Crimson and just a touch of Ultramarine at the horizon, taking the sky into the distant fields.

When this was dry, I painted the dark sky from the left with a mix of Ultramarine, Crimson and Cadmium Yellow, watering this down near the centre. I left the first yellow wash showing on the right. I also worked some dark cloud colour onto the hills and hedgerows.

Second Stage

With my No. 6 round brush, my 'Rigger', and a varying mix of Ultramarine, Crimson and Cadmium Yellow, I painted the smaller trees behind the large one and the group in the middle distance. I kept the latter 'cool' by using more Ultramarine. Then, with a mix of Bright Green and a little Cadmium Yellow, I painted the main tree trunk, leaving white paper at the base to represent snow.

I painted green on the left of the tree, adding more Ultramarine as I worked up it. Then I put in the feathery branches and painted the shadows on the side of the path.

Colours

Cadmium Yellow

Crimson

Ultramarine

Bright Green

Coeruleum

Raw Sienna

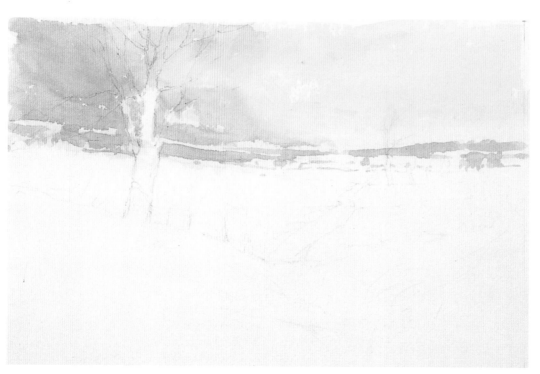

◀ First stage

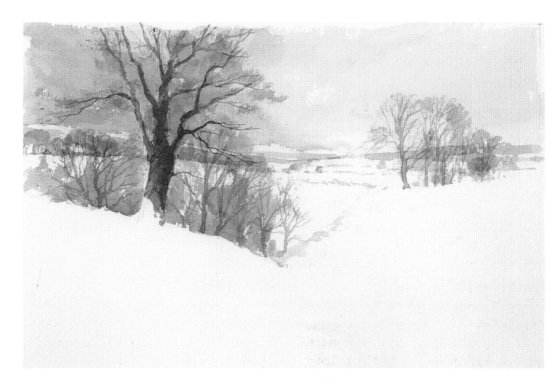

Third Stage

When you reach this stage, I suggest that you practise painting the shadows on the snow first. You can do this on any type of paper – the less expensive, the better! For the shadows, I mixed a wash of Coeruleum with a little Crimson and a little Ultramarine. I decided roughly where I wanted to put the shadows.

Then, once I was ready, I loaded my brush with watery paint and had a go. That's what you must do. As usual, with this type of painting, your results won't look exactly like mine, but whatever you achieve will be right for your painting. When this was dry, I added a few more loose brush strokes in the foreground, adding Raw Sienna to the colour.

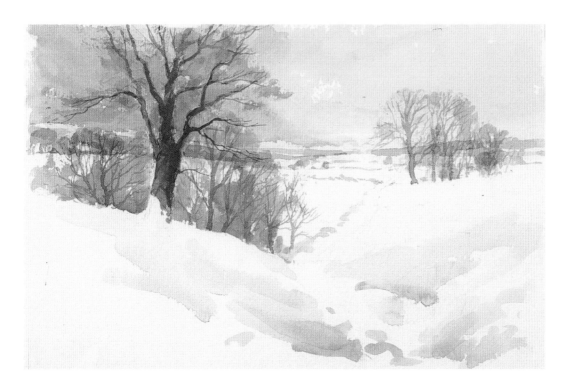

◄ Third stage

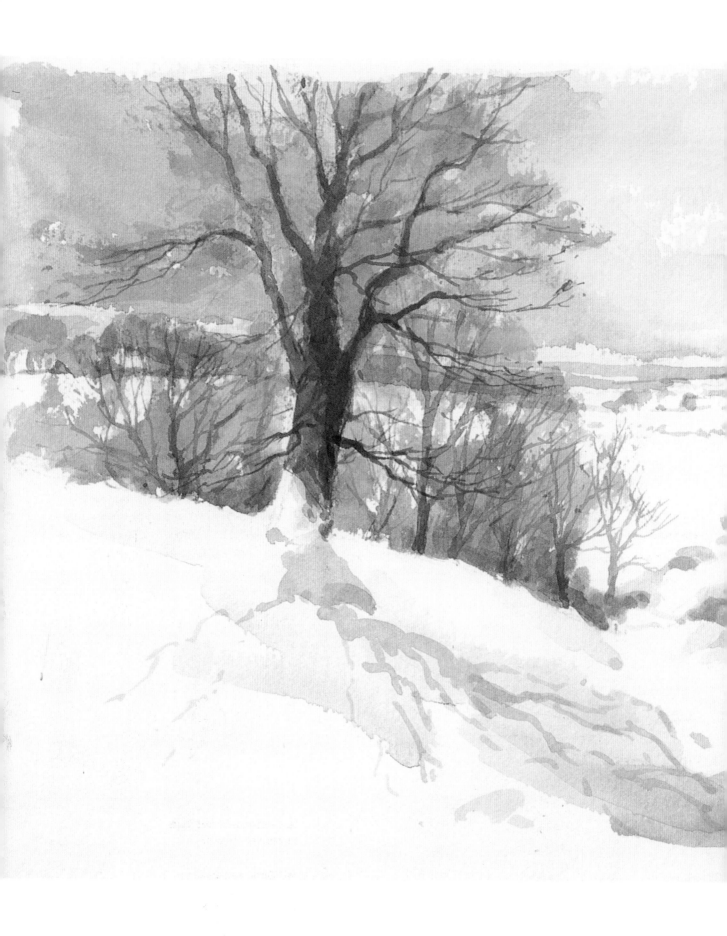

Finished Stage

I painted in the shadows on the right-hand side of the path and then, with my No. 6 round brush, put in the shadow of the large tree on the snow. When you come to do this, use my painting as a guide but remember that you won't be able to copy it exactly, so don't try.

I worked from the bottom of the trunk downwards and, since the snow wasn't flat, put in the shadows with broken brush strokes. Next, I worked on the main tree a little more, making the lower branch on the right-hand side of it darker, and adding some more darks wherever I felt the tree needed them.

Then I painted in some more shadows on the snow to give dimension. Finally, I painted some long grasses showing through the snow, adding a shadow for each clump.

▲ Detail from finished stage, reproduced actual size

◄ **Winter Landscape**
acrylic watercolour technique
on Waterford watercolour
paper 300 lb Rough
23 x 35 cm (9 x14 in)

Venetian Canal

With its countless canals, splendid squares and mysterious backstreets, Venice is an artist's paradise. Naturally, so much water with all its reflections and movement adds to the magical atmosphere. This scene, with strong sunlight on the distant buildings, dark shadows and dancing reflections in the canal really whetted my artistic appetite!

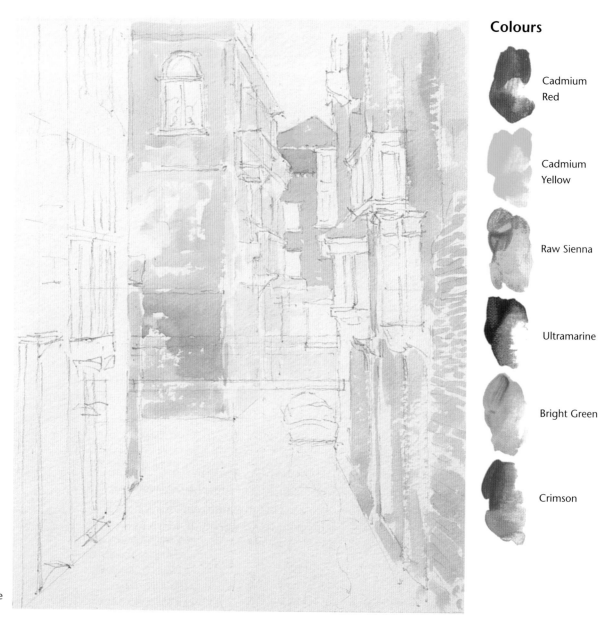

▶ First stage

Colours

Cadmium Red

Cadmium Yellow

Raw Sienna

Ultramarine

Bright Green

Crimson

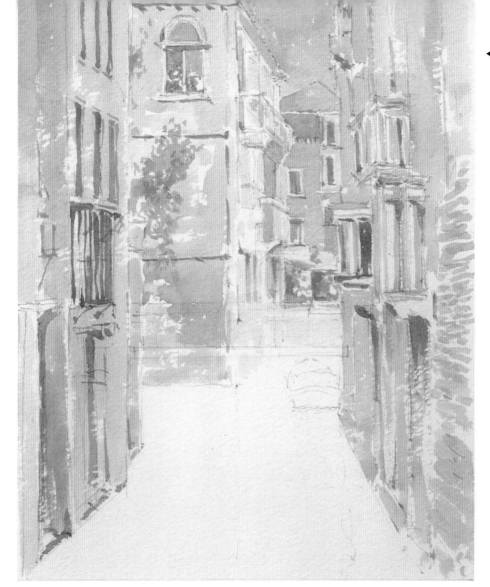

First Stage

Like the Grand Canal painting on page 50, if you are at all concerned about your drawing ability, then you may be tempted to miss this one out. On the other hand, if you don't try you will never succeed – so why not have a go?

I started by drawing the scene in with my 2B pencil. Then, using my No. 10 round brush, I started painting the sunlit buildings in the centre of the picture.

I used Cadmium Red and Cadmium Yellow on the red building, Raw Sienna and a touch of Cadmium Yellow, watered down, for the cream-coloured buildings, and then continued painting the side of the building on the left, adding Ultramarine to the mix as I got nearer to the bottom. I painted the house on the right-hand side of the picture using individual brush strokes to suggest brickwork.

Second Stage

I painted the sky first and then, using my No. 6 round brush, painted in the windows on the sunlit red building in the centre of the picture and painted a little detail on the red and cream buildings. Then I painted in the green plants, using Bright Green to do this.

I worked on the building on the left-hand side of the picture and painted in the windows and doors on all the other buildings, before putting in some simple detail. Notice how I sometimes purposely left small areas of white unpainted paper between my brush strokes. This gives different tonal values as you paint wash-over-wash, which in turn gives more life and depth to your watercolour.

You can see this effect more clearly if you look at the buildings in the finished stage, shown overleaf.

Finished Stage

I started by painting in the main shadows on the buildings. This is where the painting comes to life as the sunlit areas are made brighter (dark against light). I used my No. 10 Cryla brush and a mix of Ultramarine, Crimson and a little Raw Sienna for this. Then, using the building colours, I painted the yellowy-red reflections in the water with horizontal brush strokes (see page 39). Notice how I left an area of paper unpainted – this helped to make the water sparkle. When the yellowy-red reflections were dry, I put in the dark reflections, adding Bright Green to my mix to paint the water at the bottom left of the picture. Then I painted in the boat and the bridge. I used my 'Rigger' brush to paint the wrought iron work. When you have reached this stage, sit back and look at your painting, then add any dark accents or details that you feel will improve it.

▼ **Venetian Canal**
acrylic watercolour
technique on Waterford
watercolour paper
300 lb Rough
28 x 23 cm (12 x 9 in)

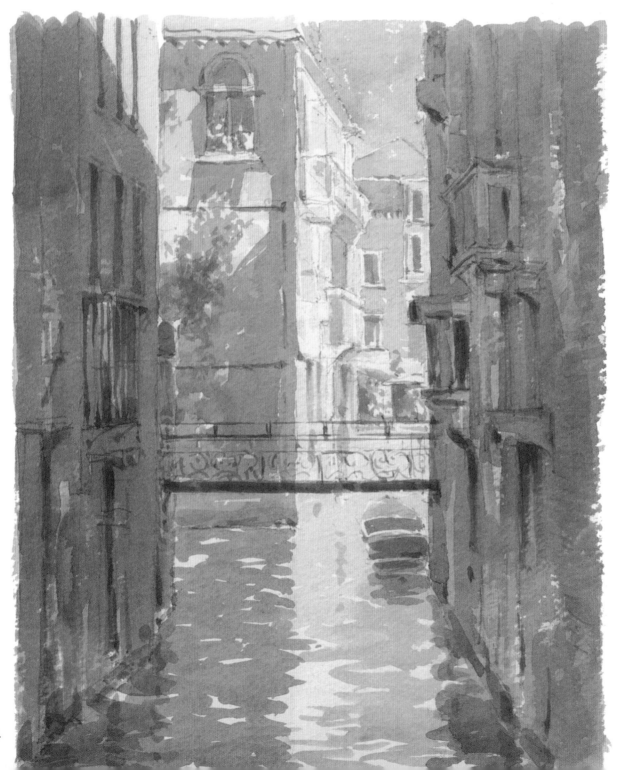